IMAGES
of America

MEREDITH

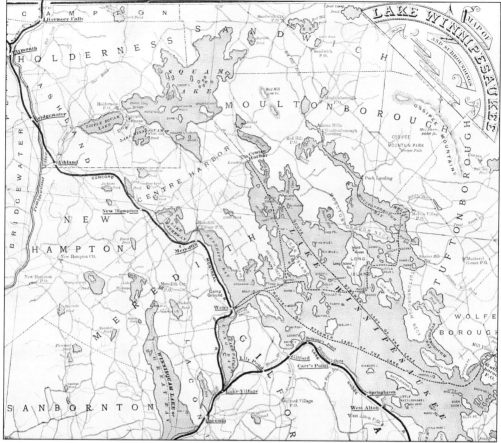

A Map of Lake Winnipesaukee and Surroundings, 1890 (Boston: Rand Avery), Issued by the Passenger Department of the Boston, Concord & Montreal Railroad.

Bruce D. Heald is the author of nine books and numerous articles and booklets about the history and heritage of the Lakes Region of New Hampshire. Presently, Dr. Heald is an instructor of humanities for Holy Trinity School in Laconia, and adjunct faculty member for New Hampshire College and Plymouth State College. Dr. Heald is a graduate of Boston University, and holds a Ph.D. in Education. He is the historian for *The Weirs Times and Tourists' Gazette*, and a fellow in the International Biographical Association and the World Literary Academy in Cambridge, England.

IMAGES
of America
MEREDITH

Bruce D. Heald, P.h.D.

ARCADIA
PUBLISHING

Published by Arcadia Publishing
Charleston, South Carolina

Printed in the United States of America

For all general information contact Arcadia Publishing at:
Telephone 843-853-2070
Fax 843-853-0044
E-mail sales@arcadiapublishing.com
For customer service and orders:
Toll-Free 1-888-313-2665

Visit us on the Internet at www.arcadiapublishing.com

To my closest and dearest friends, Robert D. & Barbara L. Bennett.

Cover Photograph: Weeks & Smith General Store, Main Street, Meredith Village, early 1900s.

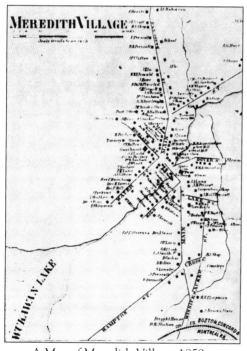

A Map of Meredith Village, 1859.

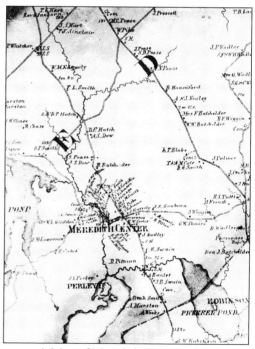

A Map of Meredith Center, 1865.

Contents

Foreword

Meredith, New Hampshire, is best known today as a four-season resort. Surrounded by four mountain ranges and clustered with many lakes, ponds, and islands, this hamlet was originally a favorite hunting ground for Native Americans.

In 1748, Palmer's Town, the first settlement of this territory, was established. The growth of the town was very slow until, on December 30, 1768, a petition for township was re-granted and incorporated, and the area was renamed Meredith, after Sir William Meredith, a prominent member of the English Parliament.

Early settlers in Meredith were men and women of a most sturdy character. They were pioneers of an extraordinary kind, and took an active part in the formation of the Granite State, stamping their individuality upon its enactments. With this spirit, many farms and industries, mills and factories, inns and hotels, and enterprises of all descriptions sprang up and flourished in the township.

The purpose of this volume is to provide a representation rather than a comprehensive overview of the town's history. Respectfully, it has been developed thematically, including the lakes and islands, homesteads, taverns, early industries, village merchants, meetinghouses, school and village scenes, and finally, reflections of yesterday.

This nostalgic photographic journey through our town is intended to enrich our historic understanding of its people; to capture the legacy, heritage, and spirit of Meredith, New Hampshire.

Introduction

Nestled in the foothills of the White Mountains, on the shore of Lake Winnipesaukee, lies the beautiful settlement of Meredith, New Hampshire. A community of superb scenery in the center of the Lakes Region, uniquely clustered with many lakes and rivers, streams and meadows, islands and bays, it is truly the "Latchkey to the White Mountains." The foot of Lake Winnipesaukee was a favorite resort for Native Americans. Large villages stood on each side of the river, and they prospered by tilling the land and fishing the lakes. Many years before the first European settlers appeared on the scene, dams were built on the rivers, for the purpose of taking shad, which swarmed there in the fall. Here, the warlike chief Wohawa called a council to inflame the neighboring tribes just previous to the bloody days of 1675, and here, the gallant but ill-fated Lovewell often halted in his raids on the Ossipees. This whole region is rich in legendary lore, and many an interesting story could be related if time and space would permit; but we must turn to more authentic documentation of our history.

In 1748, the first settlement, Palmer's Town, was made. It was named for Samuel Palmer of Hampton, who, as a teacher of surveying and navigation, had laid out much of the land surrounding Lake Winnipesaukee. It was one of the first towns to have a charter granted by the proprietors, and, as most of the lots went to prospective colonizers from Salem, Massachusetts, it was called Salem, which soon changed to New Salem. Not all of them, however, fulfilled the terms of the charter, for there were only seventeen families who actually settled in the town.

Very few of the sixty proprietors actually settled here. Many of them were land speculators who planned to sell their shares at a profit. Prior to 1769, nearly all of the proprietors' meetings were held in Stratham and Exeter, and it was there that plans for settlement were actually voted upon.

Committees were appointed to lay out the township and its divisions of lots, much of which had been completed before the Seven Years War broke out in 1754. Canada was taken over by the English in 1760, and preparations for settlement were soon resumed by the proprietors of New Salem. A bridge over the Winnipesaukee River was finished in September 1765 by Ebenezer Smith and Jonathan Shaw.

The early settlers of New Salem came to Epsom by way of the Canterbury Road, and then journeyed from Epsom to the Weirs area, thus beginning a settlement that is now referred to as the Meredith Parade. Ebenezer Smith and John Eaton were the first two settlers. Log houses were built at the head of what is now Lake Opechee around the year 1766. They seemed to like the high ground of the Parade; the first church, a tavern, the meetinghouse, the cemetery, and the pound were located there.

Growth of the town was very slow until, on December 30, 1768, a petition for township was re-granted and incorporated, and the region was renamed Meredith. The town's growth surged, with businesses and farms flourishing. However, as with many of the towns in the Lakes Region, continued development was seriously hampered by the Revolutionary War, when many took up

arms in defense of their independence. After the hostilities, they focused their attention upon town and civic affairs.

Of all the events that hit the town records, the saddest and most dramatic took place in the unfinished Town Hall at the annual meeting on March 13, 1855. Approximately 600 to 800 voters were present when suddenly the floor timbers gave way under the weight and threw about 150 persons to the basement. Of those, 60 either died or were crippled for life. Because of this dramatic event, Meredith lost a large portion of her territory in July 1855 to the newly formed town of Laconia, and in July 1873 to the town of Center Harbor.

The size of the community, however, did not dampen the spirit of growth, for many farms and industries, mills and factories, inns and hotels, and enterprises of all descriptions sprang up in the Village and the Center, on the Neck and the islands. As travel by road, railroad, and boat increased, the growing town, rich in spirit, became the magnet of the Lakes Region.

With the generosity of the Meredith Historical Society, and the many friends and neighbors who wish to preserve our legacy, a reminiscence in rare photographs has been assembled. We can recall bygone days, along with the memories of those events and people, which, over the years, have enriched our community.

Bruce D. Heald, Ph.D.

One

Lakes, Islands, and Landscapes

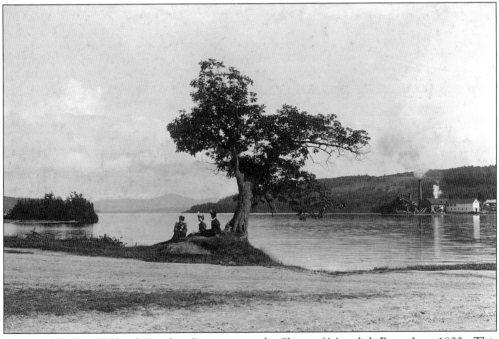

The "Old Oak" and Shook Lumber Company on the Shore of Meredith Bay—Late 1800s. This landmark stood on the shore of Meredith Bay at Clough's Park. It was a red species (*Quercus Rubra*), and its long life was credited to the fact that, although the species often grows on high land, it enjoys moist soil. The original oak marked a favorite campsite of the Winnipesaukee Indians; there was a sandy beach to land canoes, and a nearby spring provided clear cold water. The beautiful oak eventually succumbed to old age and road salt, but will long be remembered as a landmark on the park.

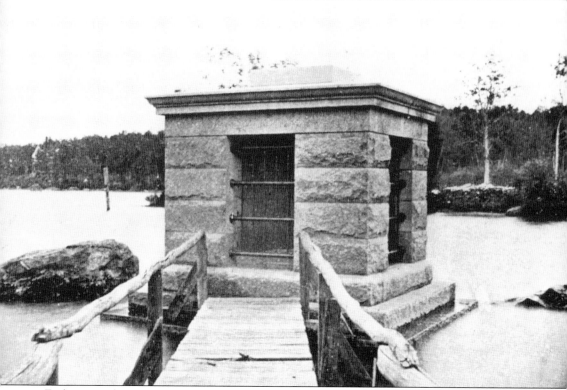

Endicott Rock Monument. In 1651, the inhabitants of Strawbery Banke petitioned for a survey of the boundaries "for the establishment of a court and for the protection against the heirs of John Mason." In 1652, Captain Simon Willard and Captain Edward Johnson were appointed commissioners by the court to determine the northern-most part of the Merrimack River. They, in turn, employed John Sherman of Watertown and Jonathan Ince, a Harvard College student, to ascertain and determine the latitude of Aquedauctan, a name given to the Merrimack River where it issues out of Lake Winnipiseogee. On August 1, they found the latitude was 45 degrees, 40 miles, and 12 seconds, besides those minutes which are to be allowed for the 3 additional miles north that run into the lake. This became the southeasterly point of Meredith (Meredith Bridge), later Weirs Beach (Laconia), New Hampshire.

The boulder was discovered in 1833 by workmen engaged in enlarging the channel at the Weirs Beach. The markings had become more or less worn by the elements by the time the state legislature appropriated money to have the rock raised and surrounded with safeguards against destruction. A facsimile of the markings on the rock was made, and is in the rooms of the New Hampshire Historical Society in Concord.

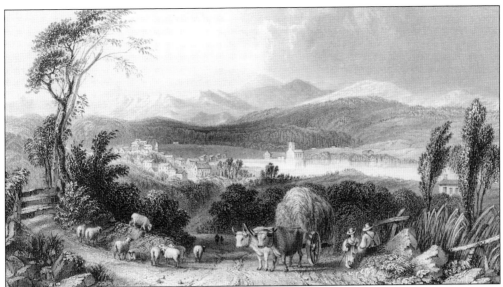

A View of Meredith Village—Bartlett Print, 1838. Meredith is located 36 miles north of the capital city of Concord, and is bounded on the north by Center Harbor and Lake Winnipesaukee; north and northeast by said lake; southeast by Laconia; south by Sanbornton; and west and northwest by New Hampton. Originally, as a farming town, agriculture was the principal employment of its early settlers. The soil was deep, fertile, easily cultivated and many farms were situated on the beautiful shores of Lake Winnipesaukee, encompassing a large portion of its southern and northeastern borders. At Meredith Village there was located one of the best water privileges in the state, which was controlled by the Meredith Mechanic Association.

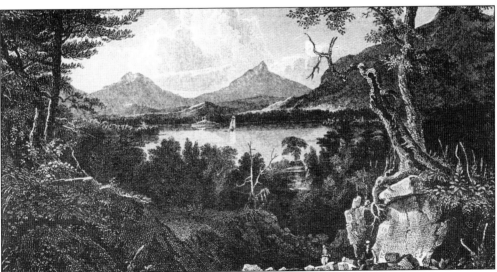

Lake Winnipesaukee—Thomas Cole Print, 1828. In addition to Lake Winnipesaukee, there are a number of lakes within the town of Meredith, including: Waukewan, Wicwas, and Winnisquam. Ponds, rivers, and streams abound the landscape and have always kept our farmland fertile. In many of the lakes there are numerous islands which dot the open waters. The many mountain ranges, including the Belknap, Sandwich, Ossipee, and Squam Mountain Ranges, frame and beautify the horizon of our community.

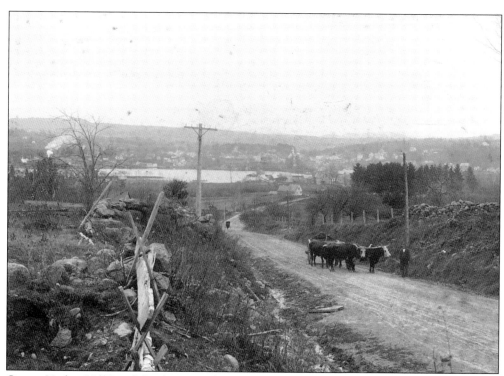

Center Harbor Hill Road, Looking South to Meredith Village and Bay, *c.* 1905.

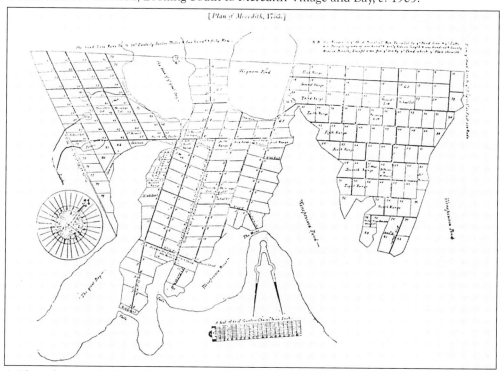

A Plan of Meredith, New Hampshire, 1753. This plan was included in New Hampshire State Papers XXIX, Vol. VI.

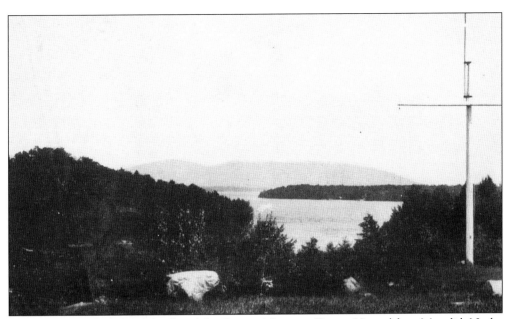

Lake Winnipesaukee, Bear Island, and the Ossipee Mountain Range, Viewed from Meredith Neck.

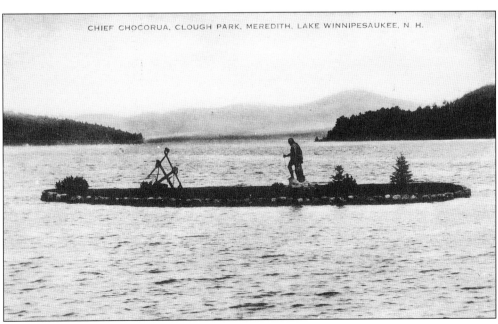

CHIEF CHOCORUA, CLOUGH PARK, MEREDITH, LAKE WINNIPESAUKEE, N. H.

Chief Chocorua, Clough Park, and Meredith Bay.

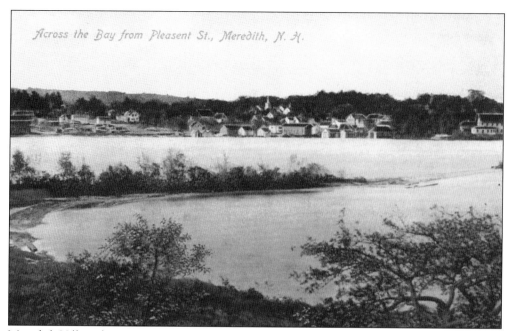

Across the Bay from Pleasent St., Meredith, N. H.

Meredith Village from across the Bay, 1920s.

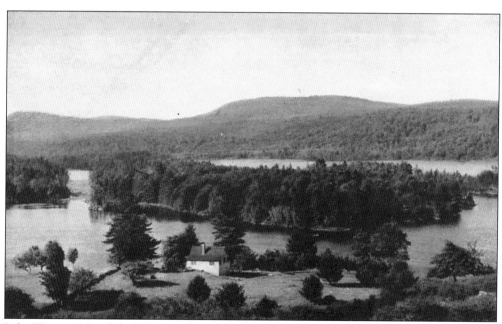

Lake Wicwas, Meredith Center, and "Camp Rudoc," Looking West to New Hampton.

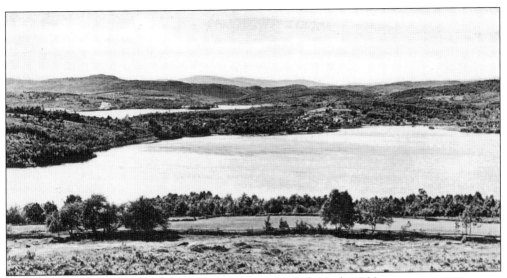

Lake Waukewan and Meredith Bay, Viewed from Meredith Neck, 1930s.

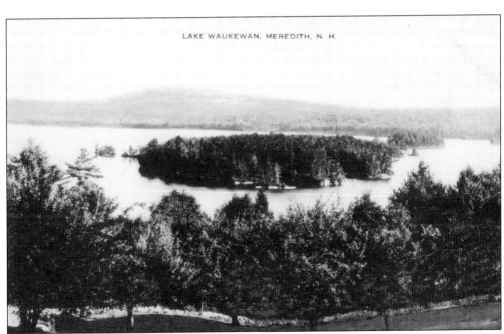

Lake Waukewan—Viewed from West Center Harbor, near Paul Perkin's Home. Lake Waukewan was once called "Wigwam Pond." Early surveyors indicated an old abandoned wigwam near the outlet in 1749, and the lake went by that name for several years. Others say it got its name by being triangular in shape like a tepee or wigwam.

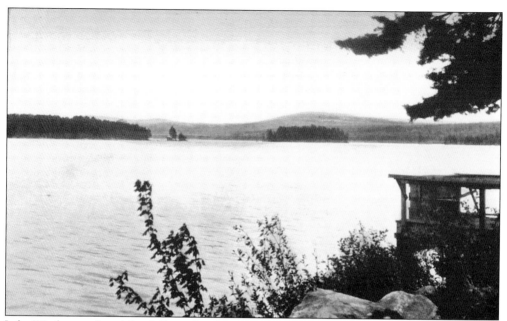

Lake Waukewan from Mayo's Point, Looking Southwest.

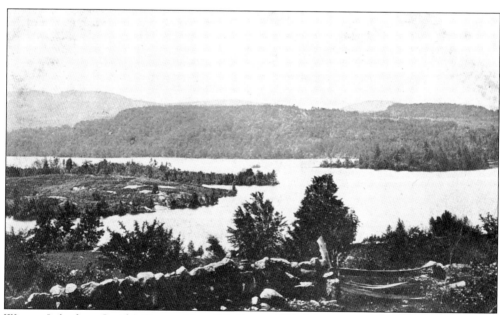

Wicwas Lake from Smith's Corner, Meredith Center. This lake is one of the most beautiful lakes in the town, encircled with majestic hills and dotted with wooded islands. On the slope of the hill stands a local church with a white spire, encircled by the village of Meredith Center, with its period homes and shaded streets.

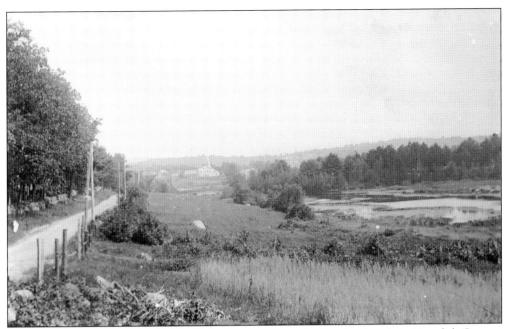

Meredith Center Road Looking South. In the distance is the Baptist church in Meredith Center.

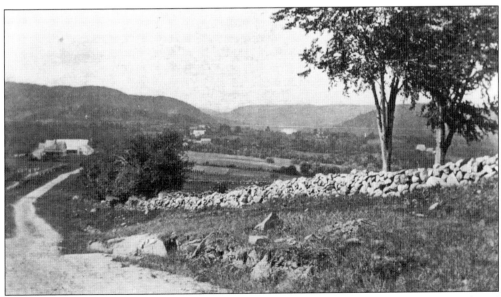

Winona Road Looking North, with the Clements Farm in the Background. During the Colonial era, this road, known then as the Province Road, was a major route from the seacoast to Canada.

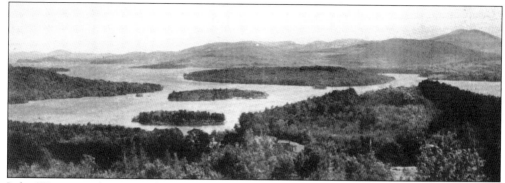

Lake Winnipesaukee. Meredith rightfully boasts of its scenic attractions, commanding, as it does, mountain, lake, and island views in nature's wonderful harmony. This is a view of beautiful Lake Winnipesaukee, as seen from Meredith Neck. In the distance, the Belknap Mountain Range frames the southern horizon.

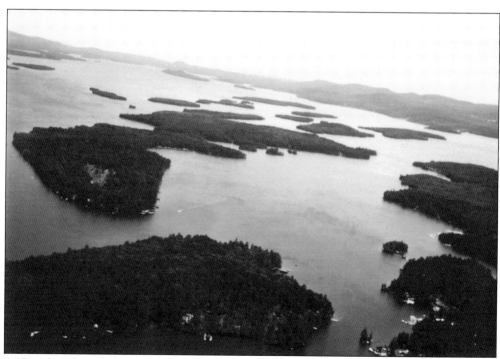

A View fron the Sky. Here we see an aerial view of a southerly exposure of Lake Winnipesaukee, featuring Bear Island in the center.

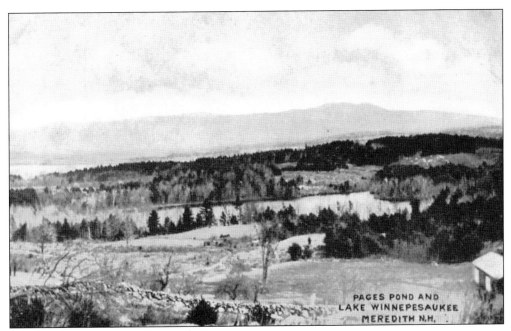

Page's Pond and Lake Winnipesaukee.

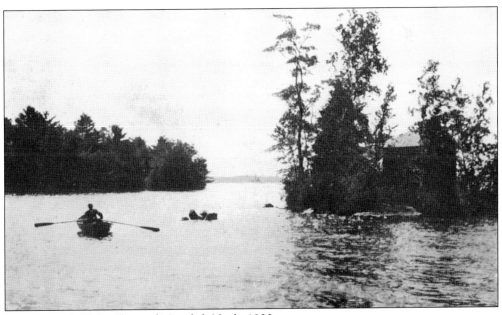

Goose Island off the Shore of Meredith Neck, 1920s.

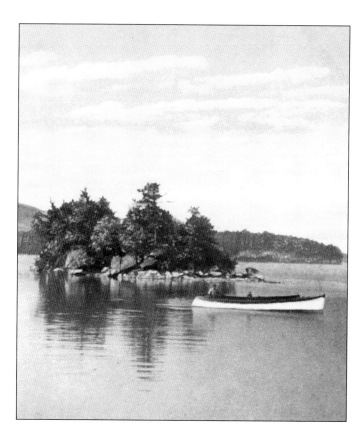

Rock Island from Three Mile Island, Lake Winnipesaukee.

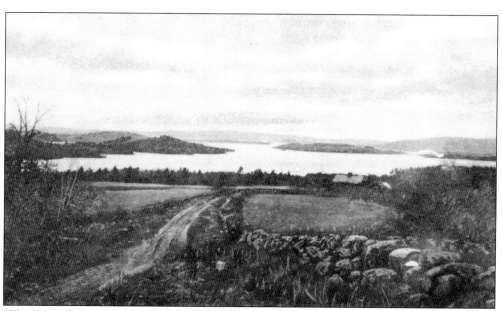

"The Weirs Road," Early 1900s. This is Route 3 south of Meredith, looking downhill toward Longridge Farm, with Meredith and Weirs Bay in the distance.

Two

Homesteads, Taverns, and Hotels

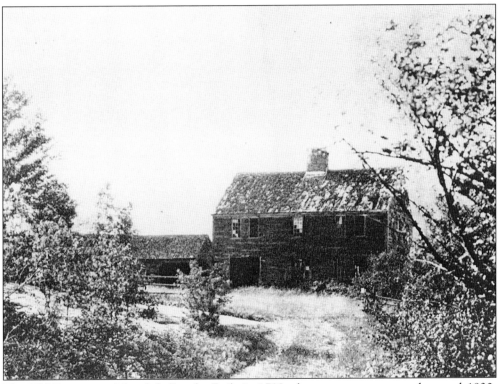

The Old Parsonage, Meredith Parade. Built in 1792, the parsonage was razed around 1930. There were many taverns and inns throughout the Lakes Region, but more particularly, along the Parade Road which connects Meredith Village with Meredith Bridge. In these taverns and inns, the early traveler and farmer could obtain nourishment or room if needed, to warm his bones, stir his tongue, and make palatable the half-thawed porridge which he ate in front of the welcoming tavern fire. The taverns were the original places of business. It was no wonder that all the men in the township flocked to them—they desired to know everything of town and state affairs, to say nothing of local scandals. Distances were given in almanacs of the day, not from town to town, but from tavern to tavern.

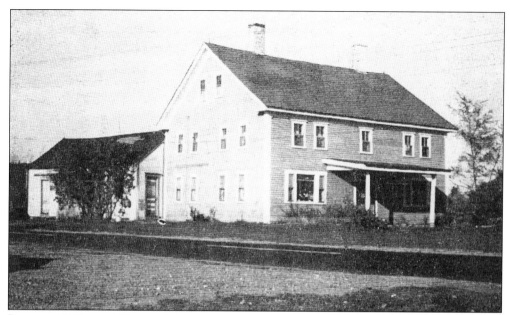

Davenport's Tavern. George Leighton, an assessor, constructed this tavern in 1785. It was a stagecoach tavern for nearly sixty years. The first tavern keeper, as far as we know, was Richard Boynton, who came from Rowley, Massachusetts, in about 1793. In 1824, Isaac Curier bought the place from Daniel Smith, who changed his name to Davenport. The initials "T.D." are on the capstone of the well across from the tavern.

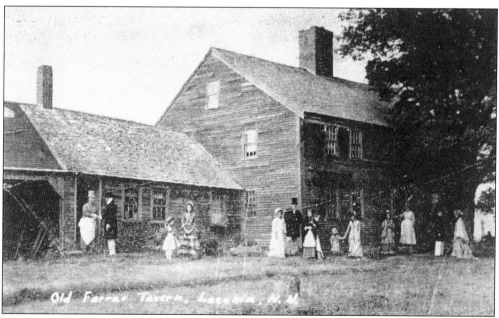

The Farrar Tavern. This 1782 tavern was located beyond the "Shad Path" on the Parade Road in Meredith Bridge (Laconia). The earliest record we find is a reference to a deed of Ebenezer Smith to his brother, Jeremiah Smith, ". . . bounded on the north by land which I this day deeded to Mary Farrar."

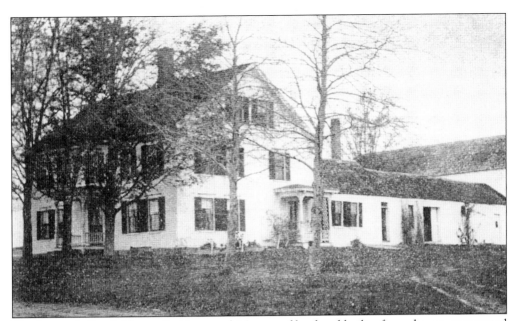

The Jeremiah Smith House. Smith owned 15 acres of land and built a frame house, as reported in Exeter on November 15, 1770. The property remained in the family for five generations. The last family member to own it was Mrs. Ellen Tilton, who died on February 6, 1947.

The John Smith Place. This home was constructed in 1808, when John Rice Smith divided the farm property. Rhoda Smith, John's daughter, lived here many years with her sister and brother. The house was sold to Joseph Gilman, and from him it became the property of Haven Marston, who recently sold it.

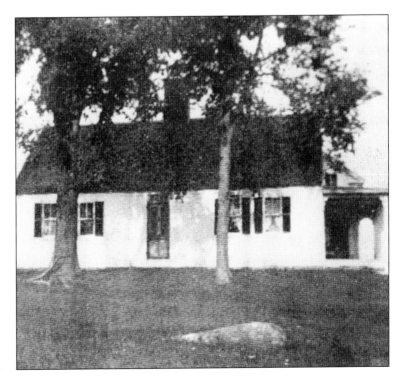

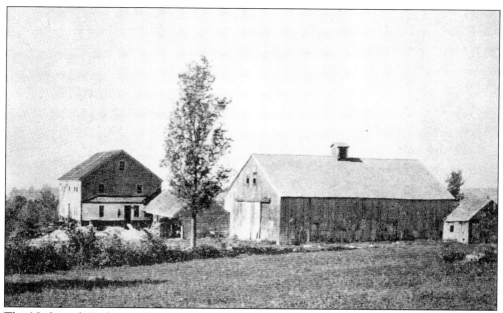

The Nathaniel Sanborn Place. Built *c. 1825*, it later became the home of his son Charles, who sold it to Jacob Sanborn (no relation), who eventually gave the property to the State of New Hampshire.

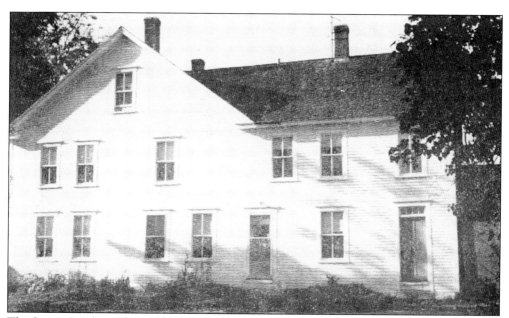

The James Crockett Place. This building, completed about 1781 by David Lawrence, was in 1811 the location of the last town proprietors' meeting.

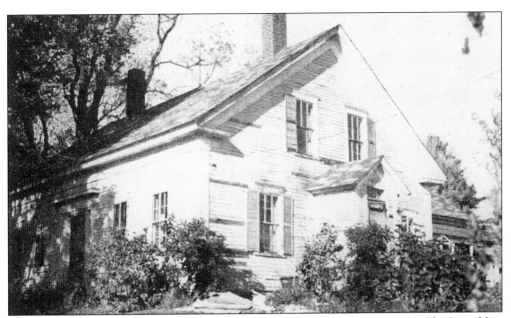

The Folson Farmhouse. This farmhouse was built by Joseph G. Folsom in 1820. The last of five generations who lived on this farm was Charles, who died in 1897.

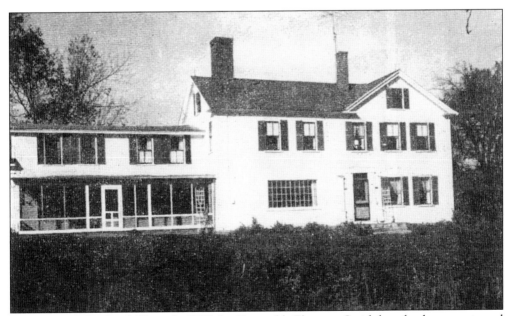

The Esquire John Smith Place. In 1773 the Honorable Ebenezer Smith bought the property and had this building constructed for his son John, who lived here until his death in 1857. For many years, it was the home of Jacob Sanborn. It was eventually sold by his heirs to W.W. Walker.

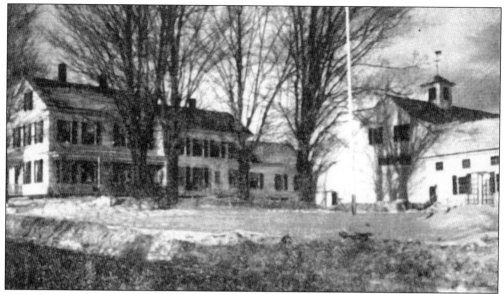

The Samuel Blaisdell Place. Constructed about 1875, the home is presently owned by South Down Shores Real Estate, Laconia, NH.

The Crockett Property. William Crockett had a long house on this property in 1770, and Joshua Crockett owned a frame house here in April 1771. The property is now owned by the State of New Hampshire.

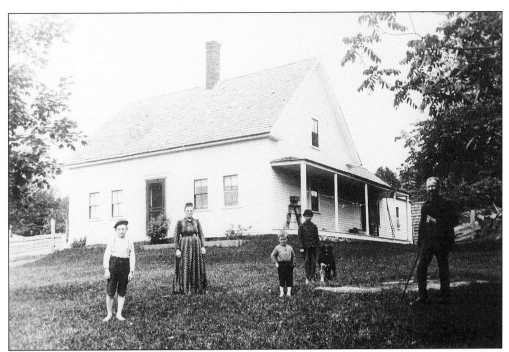

The Piper Family and Homestead, Meredith Center, NH. Pictured from left to right are: Guy, Ina, Earl, Natt, the family dog "Ned," and Mr. Piper.

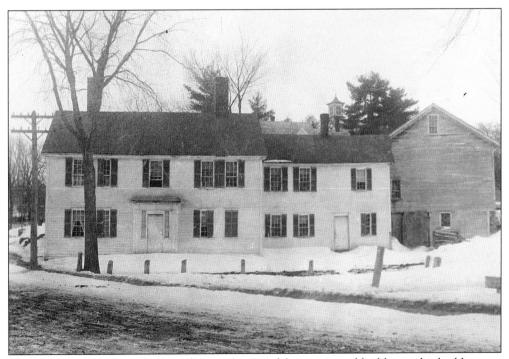

The Old Meredith House. Originally near the site of the present public library, this building was later moved to Corporation Square, and became known as the Livingston Apartments.

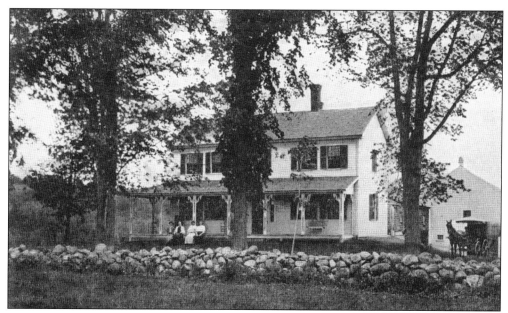

Moulton Farm, Quarry Road, 1908. Over the years, this farm has become well known to both natives and tourists for its fine produce.

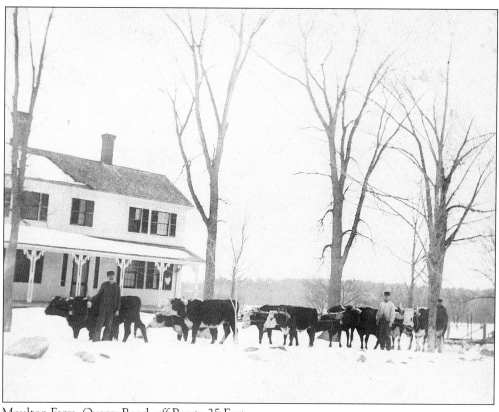

Moulton Farm, Quarry Road, off Route 25 East.

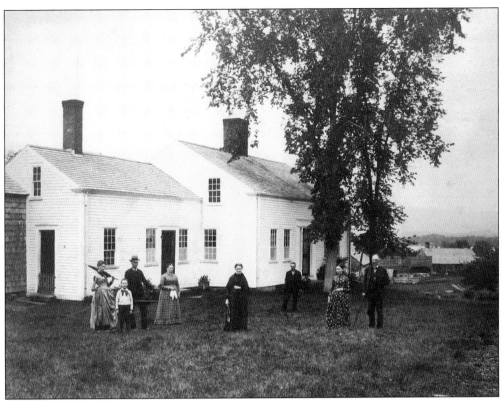

The Home of David R. Lovejoy. This house was built 1833–34. The Cabel Lovejoy House can be seen in the background. This picture was taken in 1895.

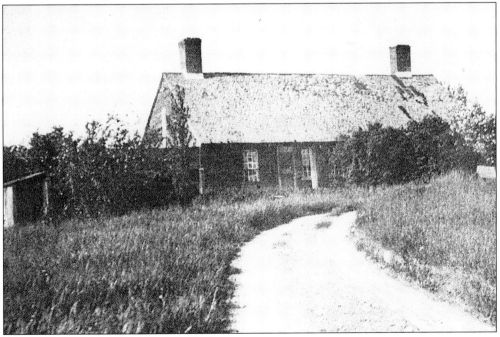

The Old Lovejoy House, Meredith Neck.

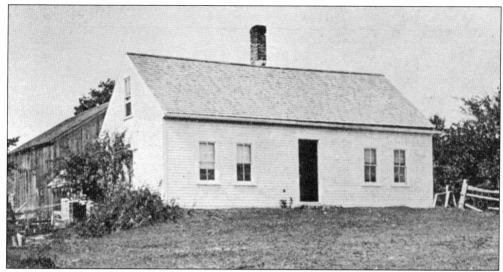

The Home of Master Dudley Leavitt. This farm was probably the finest in town. It had a wealth of pine woodland, and many valuable acres on the shore of Lake Winnipesaukee. It was passed down through the years to his family. The old homestead was located on the "Third Rangeway" branching off Quarry Road. This home is presently located on Route 25 East, approximately 100 yards from the historic marker into the town of Center Harbor.

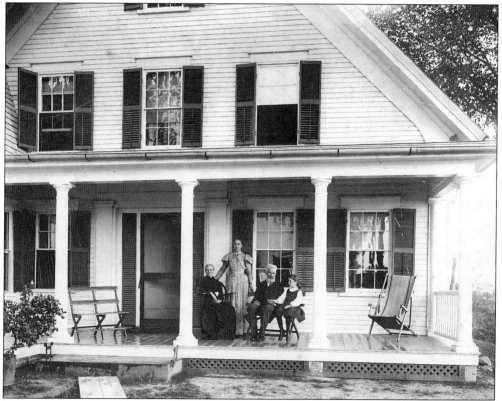

Eaton's Old Farmhouse on Spindle Point Farm, 1898. Pictured from left to right are: Lizzie Crane Eaton, Clara Davis Eaton, John Morton Eaton, and Nella Victoria Eaton.

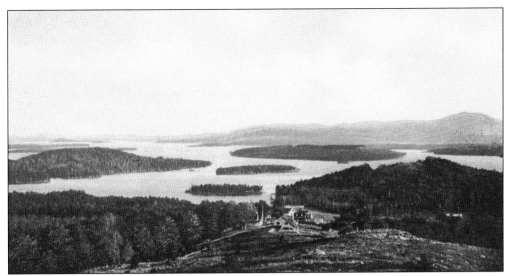

Spindle Point. This image shows Lake Winnipesaukee and Colonel Charles H. Cummings's 350-acre Spindle Point estate overlooking the "Broads." The origin of Spindle Point may be traced to a 500-acre farm owned by John Eaton, which was later sold to his son, John Morton Eaton. During the late 1800s, Mr. Eaton sold this land to Colonel Cummings.

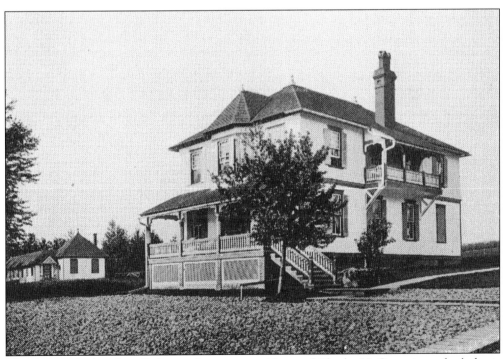

The Granite Lodge, Spindle Point. A summer residence of Charles H. Cummings, the lodge is shown here overlooking the expanse of Lake Winnipesaukee.

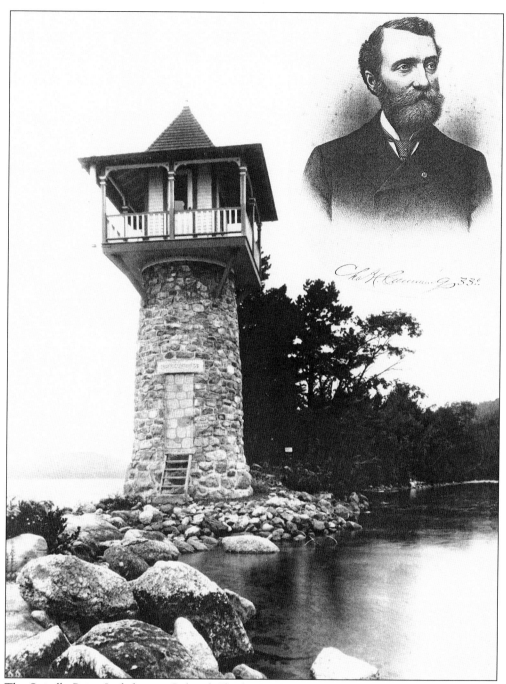

The Spindle Point Lighthouse. Colonel Charles H. Cummings built this stone tower in 1892. Located on the southernmost extremity of Spindle Point on Observation Road, Meredith Neck, this tower stands 50 feet high and is 12 feet in diameter at its base. Today it serves as a beacon for navigators and tourists alike.

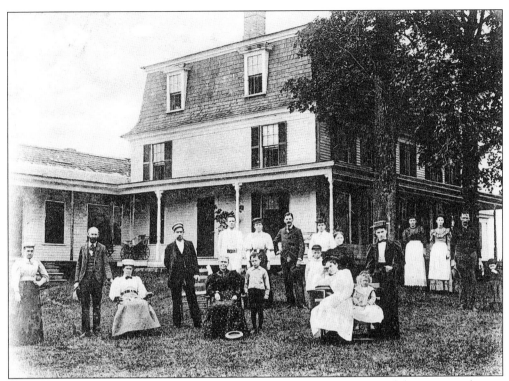

The Ballard House, the Parade Road. W.W. Ballard was the proprietor of this rooming house. The house had a capacity of twenty-five people, and Ballard charged $1 per day in 1907.

The Mountain View House. Located at the top of Center Harbor Hill Road (Route 25 East), this building is known today as the Towle House.

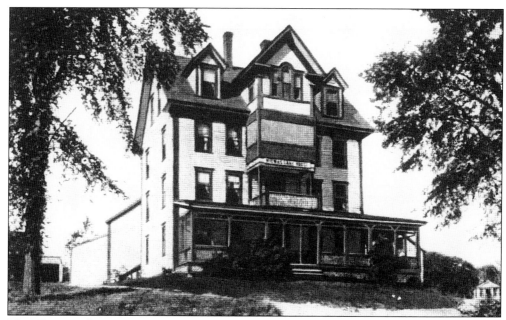

The Wicwas Lake House. Presently, this is the site of the Lakeland School on Meredith Center Road, overlooking Lake Wicwas in Meredith Center.

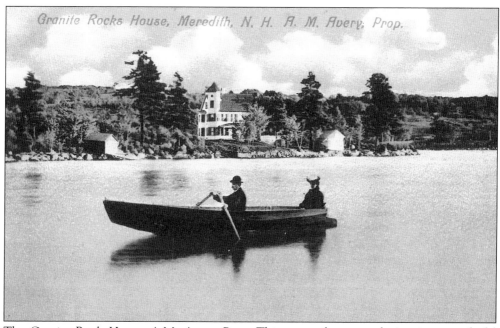

The Granite Rock House, A.M. Avery, Prop. This tranquil post card view is a wonderful advertisement for the house, located at the mouth of the canal way, Lake Waukewan.

The Maples, Highland Street, before 1932. Ellen and Aaron Clough were the proprietors at this time. The original proprietor was J.C. Dockham. The hotel had a capacity of fourteen, and rooms cost $1 per day.

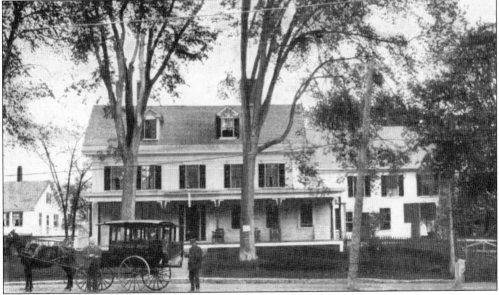

The Elm Hotel—1920. The following experience was a typical one for the many travelers who visited our village inns: "Host and hostesses sit at the table with you, and do the honors of a comfortable meal. Upon going away, you pay your fare without haggling. You meet with neatness, dignity and decency. The chambers neat, the beds good, the sheets clean, supper passable, cider, tea, punch and all, total for fourteen pence a head."

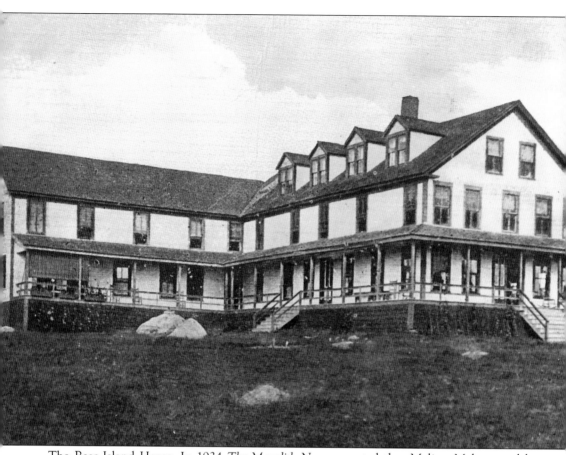

The Bear Island House. In 1934 *The Meredith News* reported that Melissa Maloon and her husband, Leonard Davis, started the hotel as a boarding house in 1879. Four years later, her parents sold their farmhouse and land to Solomon Lovejoy. The deed reads as follows: "Waldo and Abigail Maloon to S. Lovejoy being my Homestead and farm 2-2-83 for $1,186 plus mortgage of $582 to include furnishings and boat" (Book 770, p. 633, Laconia Courthouse records).

According to *Bear Island Reflections*: "The guests at Bear Island House enjoyed hiking, tennis, swimming and boating. Behind the hotel were clay tennis courts and bath houses were situated at various locations for people who went swimming . . . It was customary for boarders to stay for weeks at the hotel, which required a large staff to work in the vegetable garden, milk the cows, gather the eggs, roll the tennis courts, run the boats, and, of course, clean rooms and wait on tables."

When Solomon reached the age of sixty-five, he sold his interest to George Collins of Laconia who operated the hotel until November 7, 1922, when he sold the house and land to Coleman Blair. This fine hotel closed in October 1934, as a result of the Great Depression and the decline of tourism.

In November 1934, the building was destroyed by fire. Meredith Fire Chief Bickford was quoted in *The Meredith News*: "Firemen reached the blaze after its discovery and managed to save the barn and considerable furniture including two pianos." Fifty-five years of service went up in flames; however, pleasant memories live on for the residents of Bear Island.

Three

Town Industries
and Village Merchants

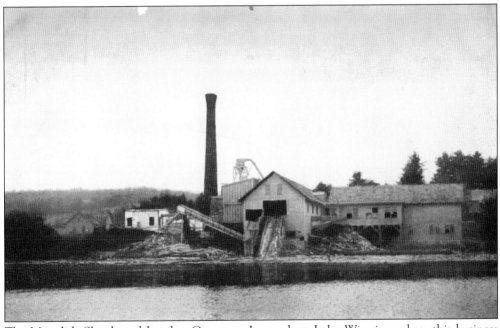

The Meredith Shook and Lumber Company. Located on Lake Winnipesaukee, this business was considered by the community as "the life of the town for many years." It is difficult to overestimate the importance of this enterprise. The company gathered raw lumber from the local countryside, took it to the lake shore, and from there used powerful little steamers to tow the lumber to Meredith Village. The location of the manufacturing company was where the Saint Charles Catholic Church is now. Mr. N.B. Wadleigh of Meredith was the General Manager. About sixty people were employed. The company was purchased by Dodge & Bliss, a Jersey City, New Jersey, company and was in existence from 1860 to 1912.

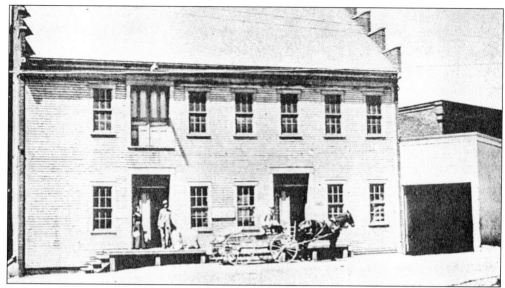

A Laconia Gristmill.

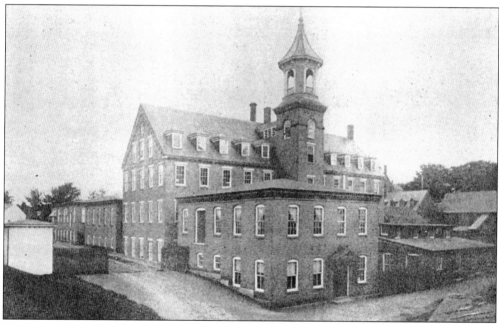

The Busiel Hosiery Mill, Laconia, (Meredith Bridge), New Hampshire. The old gristmills were as characteristic of our early town as the town hall and white clapboard community churches. In 1795, Daniel Avery built on the Winnipesaukee River just above the point where the Province Road crosses the river on the Gilmanton-Meredith border. A small but thriving settlement was growing at what was known as Meredith Bridge. In the area around the dam, several small mills were constructed, taking advantage of the water power from the river. The gristmill and sawmill are not to be confused with the factories and mills which came later. Records reveal that in 1815, a wooden structure was erected on the river under the name of the Meredith Cotton and Woolen Manufacturing Company, but was later destroyed by fire on February 13, 1823. A second brick mill was constructed and ready for occupancy in 1823.

Colonel Ebenezer Stevens, 1859. Colonel Stevens was the founder and incorporator of the Meredith Mechanics Association. It is said of Mr. Stevens that: "Among the leading businessmen whose activities, enterprise and persistent industry have been powerful motors in furthering the growth and developing the physical and moral interest of Meredith, Mr. Stevens ranks at the top of the list."

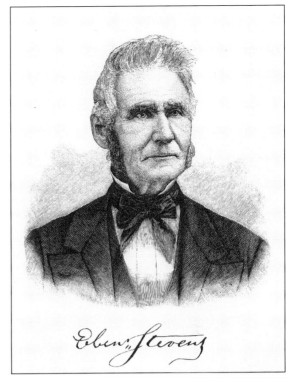

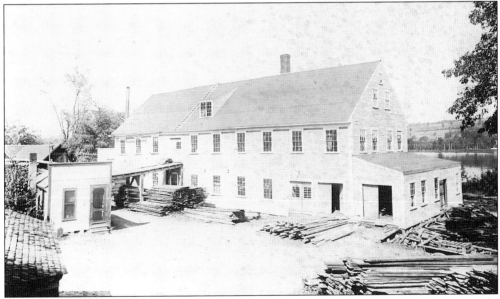

Geo. H. and J.S. Clark & Co., Manufacturers of and Dealers in Lumber and Building Materials. This establishment was located at the foot of Dover Street. The business was established in 1866, and employed about thirty-five people. The enterprise was conducted by Mr. Geo. H. Clark, and was widely known for supplying a large portion of the lumber and other building material used in this vicinity. Both George H. and J.S. Clark were natives of Moultonborough, NH. Their business was well known for manufacturing packing boxes, box shooks, dye tubs, molding frames, and brackets.

39

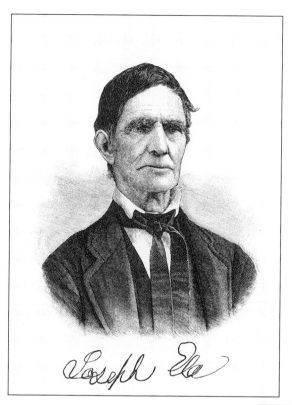

Joseph Ela (1797--1890). Mr. Ela set his residence in this town in July 2, 1822, and from that beginning became very active in both business and community affairs. In 1828, Mr. Ela was appointed deputy-sheriff for Strafford County and was deputized to act in Grafton County. He served for thirty years until Belknap County was organized, and also he served in the Belknap, Carroll, and Grafton Counties. For twenty years he was "Crier" for the courts of Strafford County, and served as such in Belknap County until 1858. In 1858, he felt it was important to form a corporation to buy and control Meredith's water power. This became known as the Meredith Mechanics Association. Among his many civic duties, Mr. Ela was also an incorporator and first trustee for the Meredith Village Savings Bank.

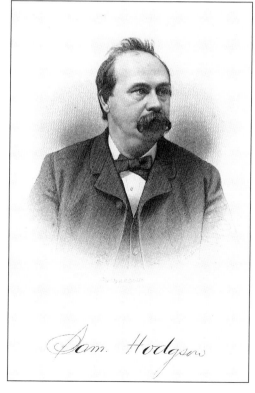

Sam Hodgson. Mr. Hodgson was the owner and operator of the Samuel Hodgson Hosiery Mill. He was born in Halifax, England, and came to America in 1866. In 1876, after many years in Lake Village, NH, Mr. Hodgson moved to Meredith Village. Here he leased the power and mills of the Mechanics Association and manufactured mittens until 1877. Shortly after the mill was destroyed by fire in 1889, Mr. Hodgson retired. He was considered by local citizens to be a kind and generous gentleman, and had the esteem of the leading men in this vicinity.

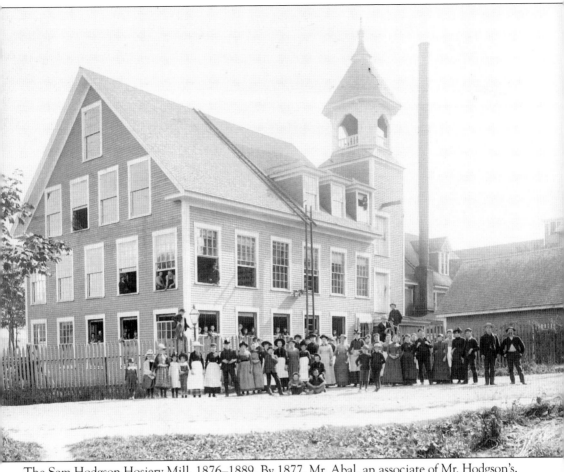

The Sam Hodgson Hosiery Mill, 1876–1889. By 1877, Mr. Abal, an associate of Mr. Hodgson's, had perfected and patented his automatic machine for knitting stockings; it revolutionized the manufacture of knitting goods. In that year, Mr. Hodgson began to manufacture stockings in the Meredith Mills. He erected new buildings, tripled the capacity of the mills, and became the principal employer in the village. In 1885, the mill employed approximately one hundred and sixty operators, most of whom were women. He believed that good wages secured good workmen and this industry added much to the prosperity of Meredith Village. The mill was located where the Mill Falls Inn and Market Place is now.

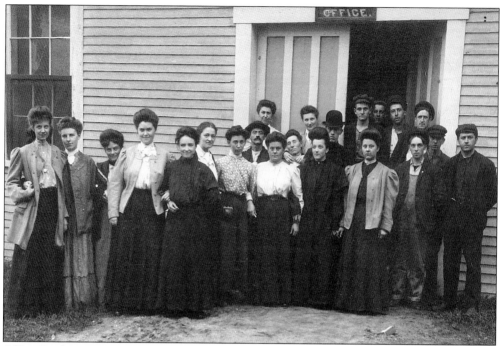

Office Employees, Hodgson Hosiery Mill, 1877.

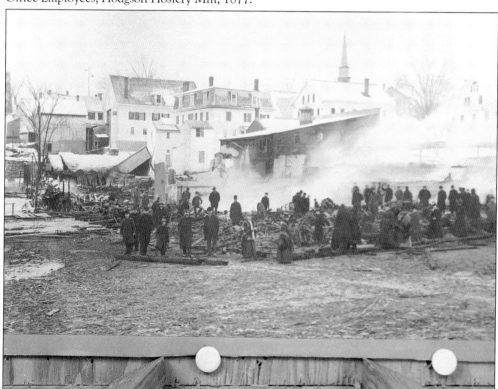

Sam Hodgson's Mill Fire. This image shows the smoldering ruins of the Hodgson Hosiery Mill after fire destroyed the building on December 28, 1889.

The Meredith Grain & Lumber Company, Mill Street, Early 1920s. Located at the lower end of Main Street in Meredith Village, this company was an important industry for local farmers and builders. Pictured are: Rutherford Anderson, William Lloyd, Arthur Edwards, and Ethel Dorais.

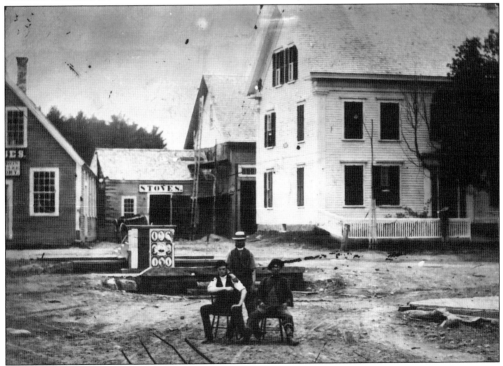

Pynn's Store, Early 1900s. Mrs. Moses' house (right) on Main Street later became known as Harvey's Drugstore. Pynn's Store can be seen it the center, toward the rear. To the left is the present location of "For Every Season."

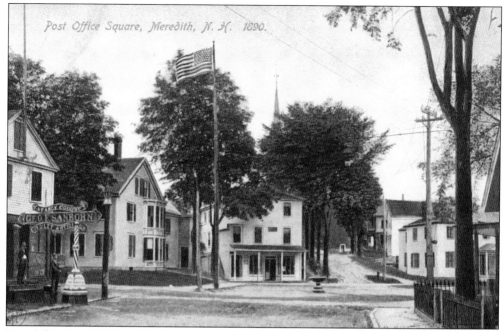

Post Office Square, Meredith Village, 1890. This view shows the junction of Main, Water, and Highland Streets. Sanborn's Drug Store is on the left, and the Meredith Post Office (presently the Historical Society) is at the center.

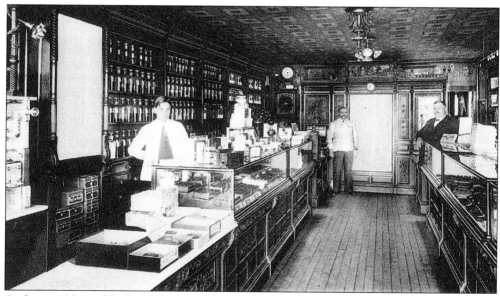

An Interior View of Sanborn's Drug and Variety Store, 1906. This store, located on the corner of Main and Water Streets, later became Samaha's Clothing Store. This view shows Mr. Sanborn (right) and his son Royal (left). An unidentified chemist is pictured at the rear.

1883. The Best Stocked Store in Town. 1908.

SANBORN'S

THE REXALL STORE.

Our

Remedies

Cure.

Our

Bargains

Talk.

Meredith's Headquarters for Fancy Goods, Toilet Requisites, Souvenirs, Post Cards, Cameras and Supplies.

WATCHES, CLOCKS, JEWELRY. SPECTACLES AND EYE GLASSES.

Daily Papers, Periodicals, Pipes, Tobaccos, Cigars, Cutlery and Sporting Goods.

OUR UNEQUALLED ICE CREAM AND SODA PLEASE THE PEOPLE

1908 *April* 1908

Sunday	Monday	Tuesday	Wednesday	Thursday	Friday	Saturday
8TH FIRST Q.	16TH FULL M.	23RD LAST Q.	1	2	3	4
5	6	7	8	9	10	11
12	13	14	15	16	17	18
19	20	21	22	23	24	25
26	27	28	29	30		30TH NEW M.

APRIL—FOURTH MONTH.

REAL ESTATE. **COAL.** **INSURANCE.**

NEWS JOB PRINT, MEREDITH

Sanborn's Rexall Calendar, 1908.

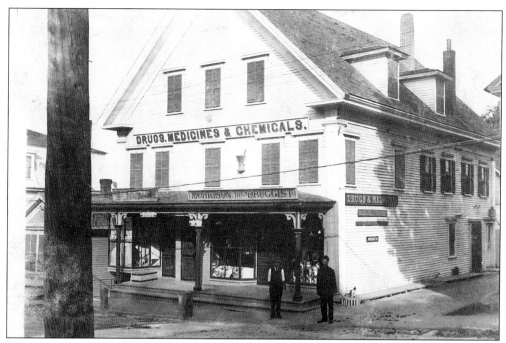

Morrison, Druggist, the Wadleigh Building, Main Street, Meredith Village, mid-1800s. This building, located beside the Blaisdell Insurance Agency, was later known as the IOOF (Odds Fellows Hall).

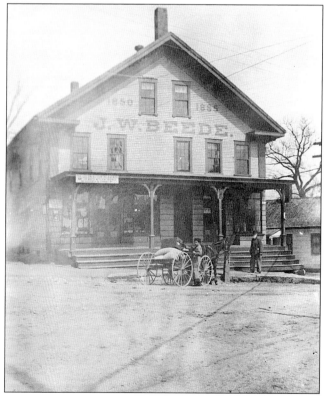

J.W. Beede—General Merchants. J. Fred Beede was a native of Meredith. He was educated in the "Red School House" on Plymouth Street, graduated from Tilton Seminary, attended Boston University, and graduated from Yale University in 1882. After being in the banking business for a few years, he resigned and returned home to assist his father, who was the proprietor of a general store. In 1885, his father died and J. Fred carried on the business until he sold it in 1922. This store was located at the intersection of Main and Plymouth Streets across from the present location of the Mill Falls Inn & Market Place at the lights in the village.

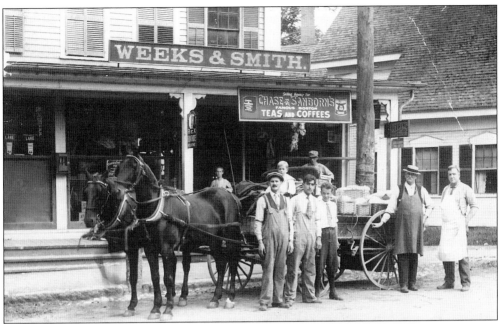

The Weeks & Smith General Store, Main Street, Meredith Village, Early 1900s.

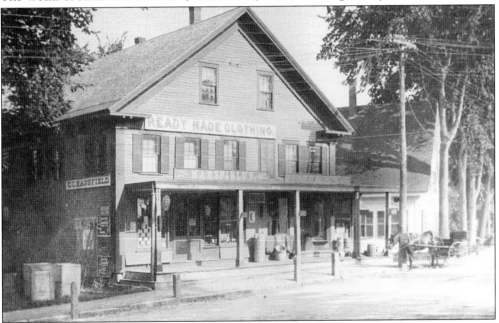

Edward C. Mansfield Dry Goods and "Ready Made Clothing," c. 1880s. In 1838 Captain Joseph Lang started a dry goods business on Main Street at Post Office Square, in what was originally known as the Lang Building. It later became a grocery store operated by John Knowles, and then by Pease & Towle. Mr. Lang is better known as the captain of the 12th New Hampshire Regiment during the Civil War. The hall above his store was used to recruit soldiers for the 12th Regiment. During the mid-1900s, Sam Grad and sons, Linden and Will, also operated this property as a quality clothing store. It is presently the home of the Alexandria Antique Store across from the Meredith Historical Society, Meredith Village.

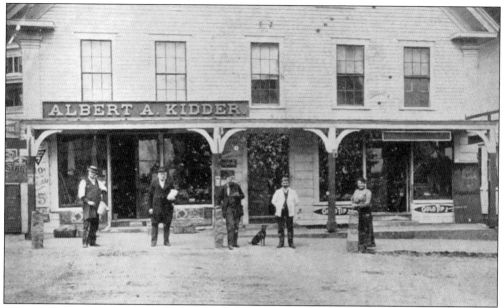

Albert A. Kidder & Co., Dealer in Fancy and Family Groceries and Boots, Shoes, and Rubbers. This business, established in 1881, was located on Main Street. A full line of fancy and family groceries was a prominent feature. The firm's specialties were fine cigars and tobacco, and it carried the largest line and the finest brands of cigars in town.

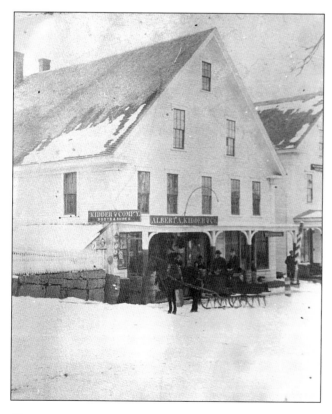

The Albert A. Kidder Store, Lower Main Street, Meredith Village.

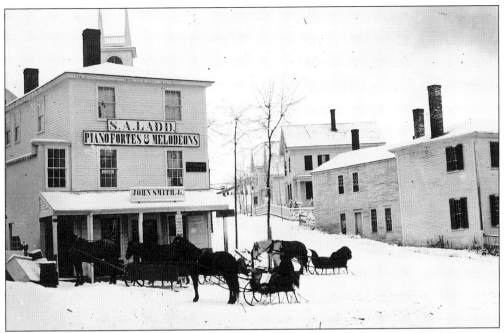

S.A. Ladd Pianofortes & Melodeons, located "On the Square." In 1859, after his carriage manufactory was destroyed by fire, Mr. Seneca A. Ladd rented a vacant cotton factory, and for the next eighteen years engaged in the manufacturing of pianos and melodeons.

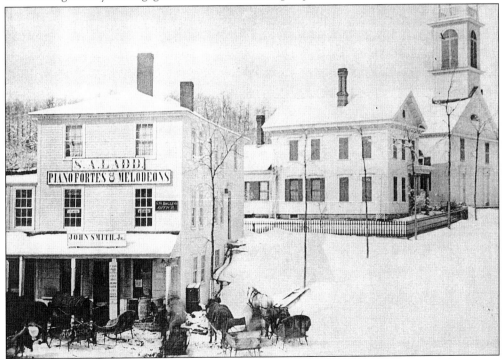

In 1869, with his hearing impaired, Ladd gave up this business and soon conceived the notion of starting a savings bank—thus establishing the Meredith Village Savings Bank. This building is presently the home of the Meredith Historical Society.

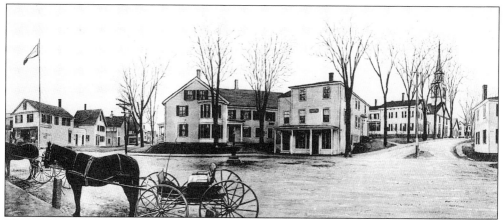

The First Home of the Meredith Village Savings Bank at Post Office Square. The Ladd Building, at the corner of Main and Highland Streets, is shown here, *c.* 1895.

The Meredith Village Savings Bank, 1920s. The entrance to the bank office is located in the center of picture, above the post office. Presently this edifice is the home of the Meredith Historical Society. Mr. Seneca Ladd's house, located on the right on Highland Street, is now the Meredith Municipal Building.

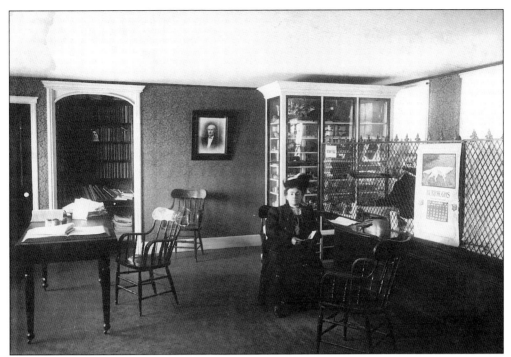

The Interior of the Meredith Village Savings Bank in 1905. Shown here are Seneca Ladd's daughter Virginia, and behind the teller's cage, bank treasurer D. Emery Eaton.

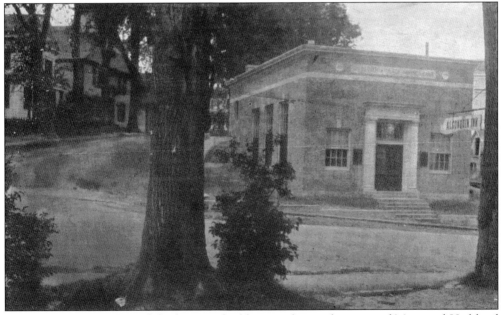

In 1924, the Meredith Bank built a new building on the north corner of Main and Highland Streets. This is presently the site of the Meredith Municipal Building.

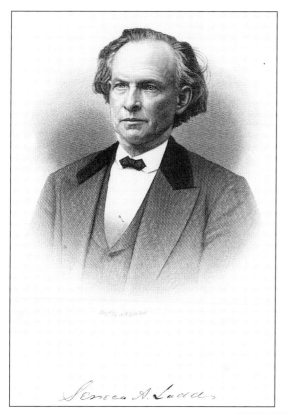

Seneca Ladd, founder of the Meredith Village Savings Bank, 1869. "Seneca A. Ladd was a man who had deeply at heart the welfare and upbuilding of the town in which he spent fifty-six years of his life. As original in mind, as thorough in everything he undertook, he did a great deal to instill these qualities into the character of those around him" (Ruth C. Colby).

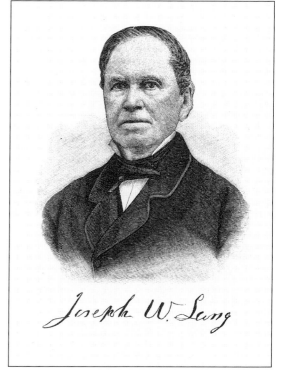

Joseph W. Lang. No one has been more identified with every phase of town business, or had a higher place in the esteem of the townspeople, than Mr. Lang. When the Meredith Village Savings Bank was organized in 1869, Mr. Lang was elected its first president. He was also incorporated the Meredith Mechanics Association in 1859.

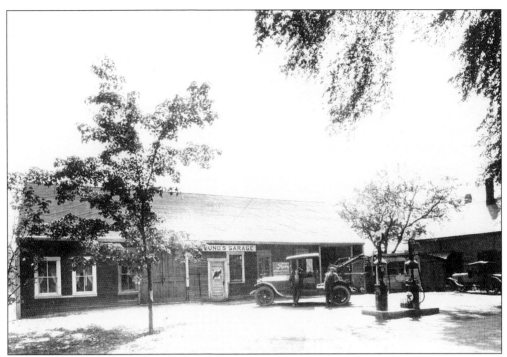

Olin Lund Garage, Plymouth Street, Early 1920s.

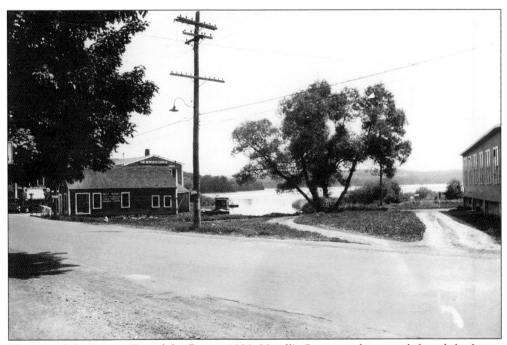

The Meredith Garage, Top of the Bay, c. 1930. Vinall's Garage is shown at left and the Linen Mill is on the right. This is the present intersection of Routes 3 and 25 East. The arrow sign on the tree points to the Pinnacle Park Zoo.

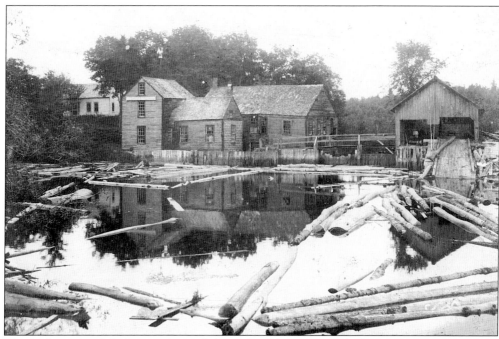

The Mill at Meredith Center. Around the turn of the century, the logging contractors began replacing horses and oxen with steam-powered engines. The first and possibly the most famous of these was the Lombard Log Hauler.

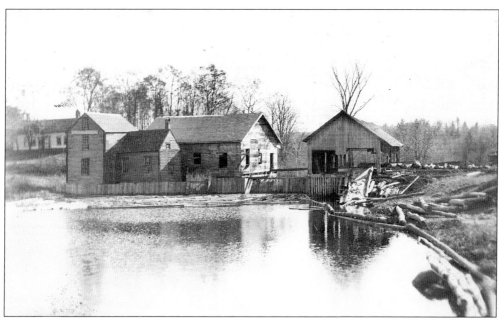

The Mill at Meredith Center. This mill was operated by water power up through 1925. The old grist and sawmills were vital to the community. In 1796 Timothy Dwight observed: "There is probably no country in the world where millstreams are so numerous and universally dispersed, or gristmills and sawmills so universally erected as in New England."

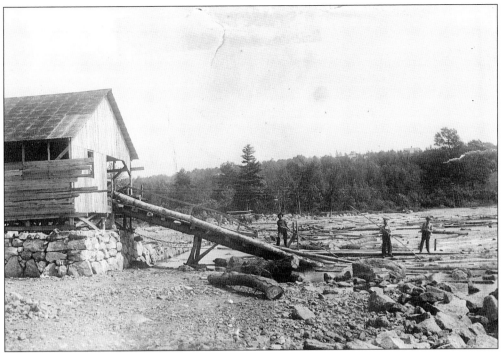

Ed Wiggin's Saw Mill on the Shore of Lake Waukewan, c. 1900. The early sawmills were designed simply, as a long shed, but wide enough to cover what machinery was needed, and long enough for an uncut log to be laid at one end and a cut log at the other after being passed through the saw at center point.

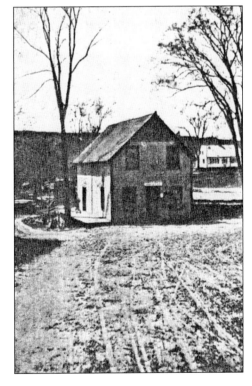

The Meredith Center Post Office.

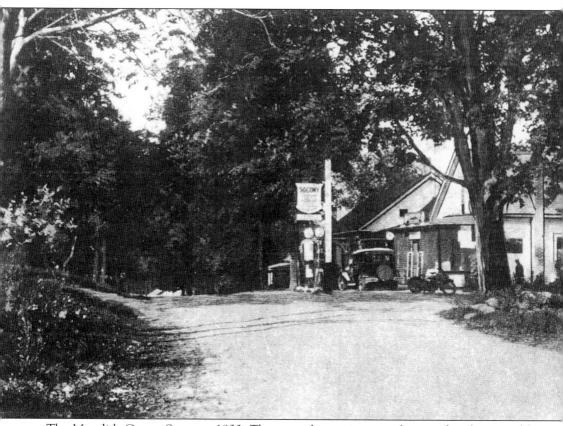

The Meredith Center Store, c. 1930. The general store is presently owned and operated by the Joseph Pelczar family. It is quiet—not silent—just pleasantly quiet. The proprietor speaks to a customer in a low, easy voice. The business seems almost confidential. The order is gradually filled. The proprietor writes down figures on a brown paper package, leisurely adds them up, yawning comfortably, accepts payment, and the customer unobtrusively leaves the store.

Now it's your turn to be waited on. Perhaps all you want are crackers and cheese. Quietly, the proprietor slices the cheese with a large knife, and, as you eat, you engage him in some political conversation of the day. No heavy intellectual repartee, just a chat, slow and punctuated by many long pauses. The old clock ticks softly on the wall. A cat naps in the window among the dried fruit. Ax helves and cantdogs, lumbermen's stockings and felt boots, candy kisses and cans of beans wait patiently about. A wood chunk in the stove rolls over and the proprietor puts in another one. The fire sings cheerily in the flue. The clock goes on ticking. The store goes on living. It will be there tomorrow.

Four

Meetinghouses, Schools, and Village Scenes

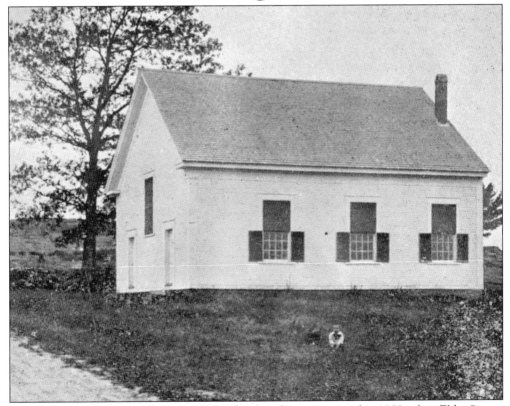

The Freewill Baptist Church of Meredith. The church was organized in 1800, when Elder Simon Pottle of Middleton came to the part of town known as Oak Hill (2.5 miles from the village), and held meetings there. This church has been called the "Pottle Meeting House" and the "Oak Hill Meeting House."

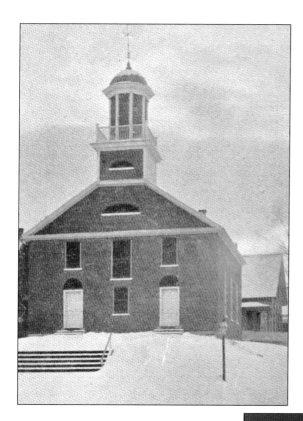

The Second Baptist Church. The Baptist Society was incorporated on December 14, 1797, and continued to minister to a large parish until May 20, 1831, when thirteen members requested a dismission for the purpose of organizing the Second Baptist Church in Meredith Village. "It was decided to build a meeting House of brick 'upon a rock' on some land 40 x 50 feet in the Village in 1834." In 1860, the Second Baptist Church was renamed the Meredith Village Baptist Church.

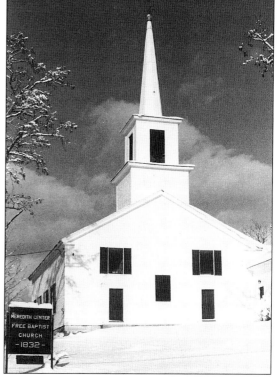

The First Baptist Church of Meredith Center. In 1810, fifteen men and women organized a church at Meredith Center with the assistance of Reverends Stephen Pitman and David Knowlton. Originally, it was called Freewill Baptist Church of Meredith. The present church edifice was erected in 1831, meetings are currently held year-round.

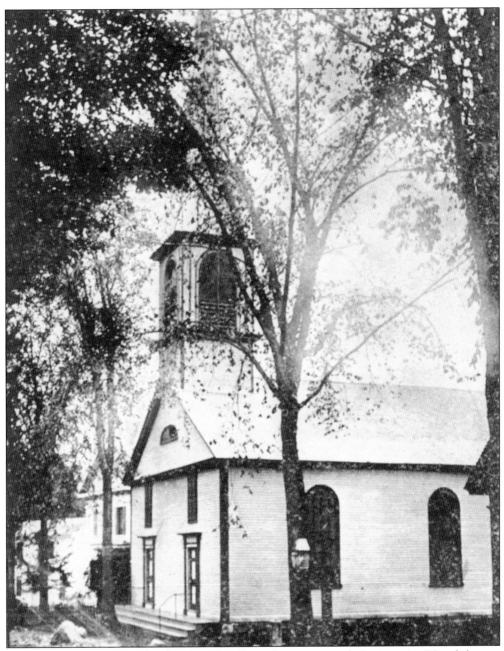

The First Congregational Church. The First Congregational Society in Meredith was incorporated by a special act of the legislature in 1817, authorizing it to transact its legal business. The first meeting of the society was held in David Bean's inn. The first meetinghouse was situated about a mile from Meredith Village on Center Harbor Road near the Towle Place. On April 20, 1831, the name First Congregational Church in Meredith was adopted. In 1833, a meetinghouse was built near the Frank Clough Home opposite the Old Oak on the Lake. The church remained there until 1842, when it was moved to its present location on Highland Street. At that time, there was only one house beyond the Ladd Block and that belonged to Deacon Furber, who lived where the Beede House is now located.

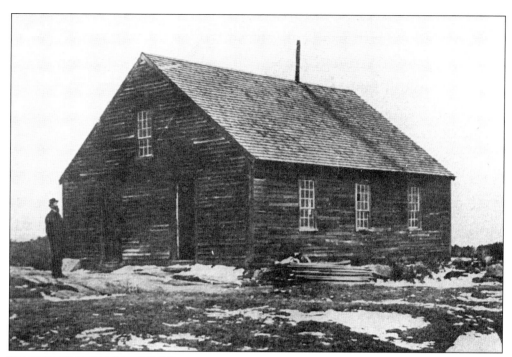

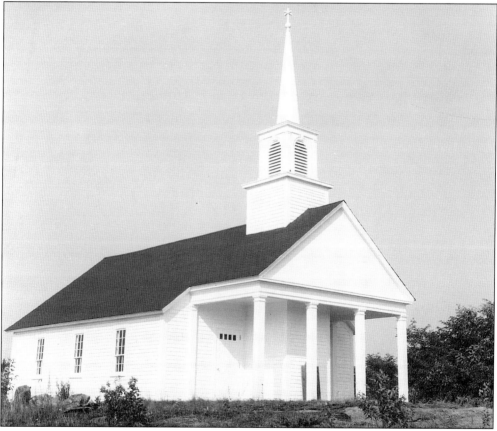

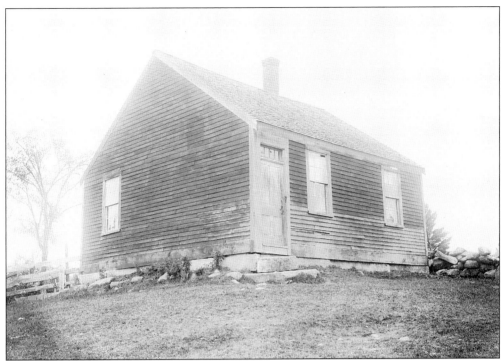

A Rural District Schoolhouse. This was a typical one-room schoolhouse for grades one through eight, located in the western section of the town. The chief goal of the district school was to provide the young scholars with rudimentary instruction at a low cost under firm community control. The most characteristic school in town was the District School, organized and controlled by a small locality and financed by some combination of property taxes, fuel contribution, tuition payments, and whatever state aid was available. Beginning in the late eighteenth century, this district system became prevalent throughout Meredith, the Lakes Region, and all of New England, as population dispersed outward from towns, and outlying neighborhoods demanded control over their schools. During 1845, twenty-three school districts existed in the town. There were thirty instructors employed during the school year; twenty-four were examined and received certificates.

Top left: The Meredith Neck Meetinghouse. The meetinghouse was constructed in 1839 by Neck residents who separated from the Village Free Will Baptist. The site was deeded by Stephen Boardman to Daniel Wiggins (as trustee) for a church, as long as services are held there. A few years after it was built, it was passed on to the Adventists.

Bottom left: The Meredith Neck Union Church, Remodeled 1898. As late as the second or third decades of this century, the church remained the center of religious worship and social activity for the community. In 1955, this edifice was again remodeled. Now, except for an occasional marriage or funeral, it is used primarily during the month of August for services. Several prominent summer resident ministers take turns giving sermons here.

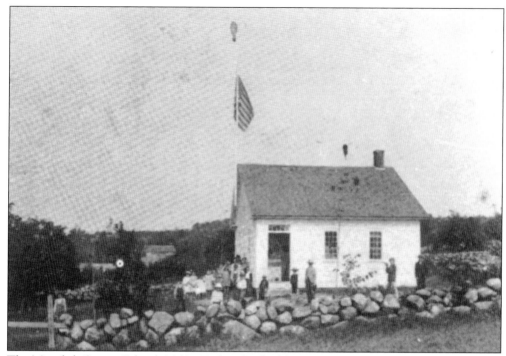

The Meredith Center School, 1860s. Today, this building is used as a private home overlooking the Meredith Center playground.

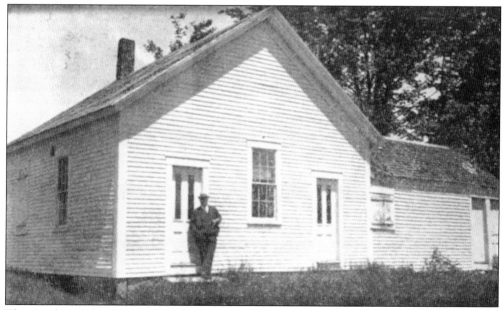

The Crockett School House. This building was last used as a school 1922–23. It was eventually sold by the City of Laconia to Mr. Earle Flanders on October 5, 1929.

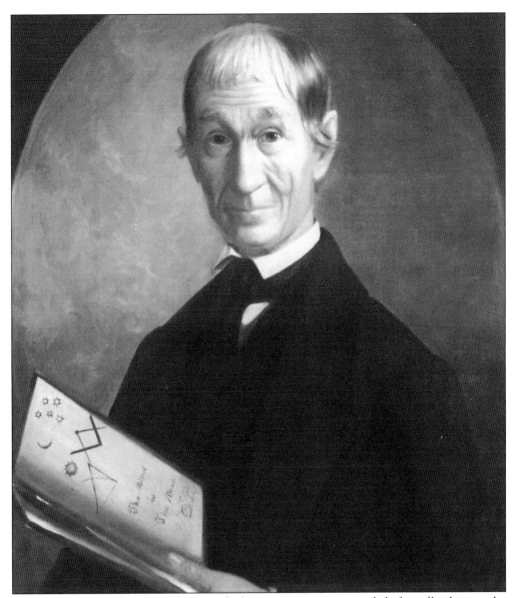

Dudley Leavitt. During the early days of education, one name stands before all others as the predominant teacher in New Hampshire: "Master" Dudley Leavitt (1772–1871). So influential was his teaching that scholars from hundreds of miles traveled to the Lakes Region to learn from him. Not only did he teach in our public schools, but he also taught privately in his home, established the Meredith Academic Academy, and wrote several published texts, including the *Teacher of Common School* and his annual *Farmer's Almanack*. This gifted man of many talents gave dignity, prestige, and personal sensitivity to the educational needs of young and old alike in our town and state. His accomplishments as an educator and citizen of distinction gave much to the moral fiber of our New Hampshire citizens.

"Master" Leavitt's image has been preserved through this portrait. The image was painted by the well-known artist Walter Ingalls, of Gilmanton, two years before "Master" Leavitt's death. The painting is now on display at the New Hampshire Historical Society in Concord, New Hampshire, as a gift of a Committee of Nine (1875).

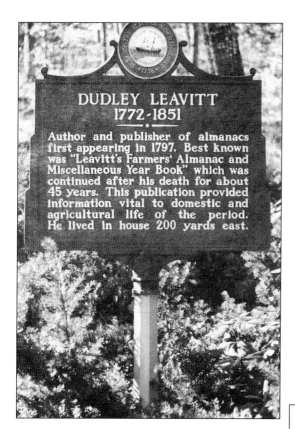

The Dudley Leavitt Historic Marker. The marker is located on Route 25 East, at the Center Harbor town line, approximately 100 yards south of his homestead.

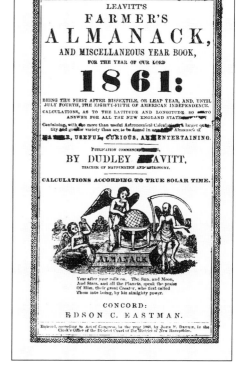

Dudley Leavitt, *Farmer's Almanack* , 1861. "Master" Leavitt compiled and calculated his Farmer's Almanac from 1797 through 1854.

Two Views of the Schoolhouse on Center Harbor Road, Built 1870.

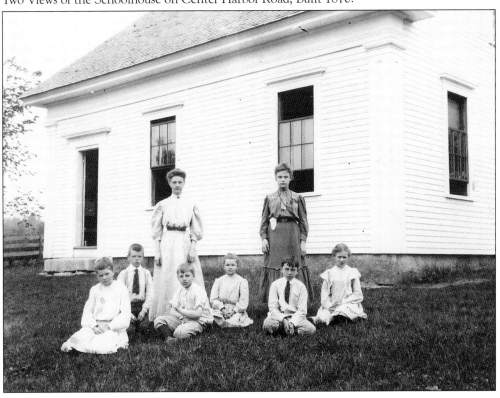

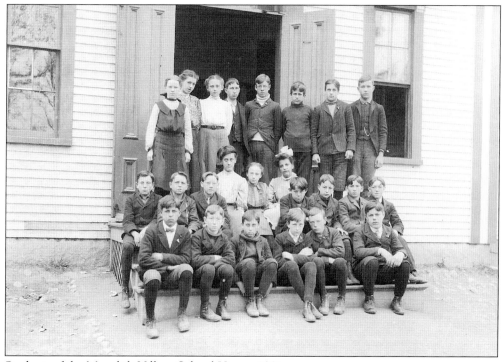

Students of the Meredith Village School House, 1901.

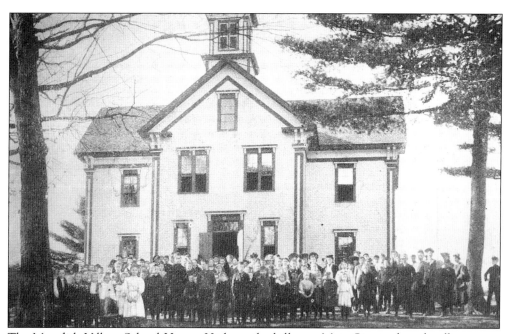

The Meredith Village School House. High on the hill over Main Street, the schoolhouse was the center of local education until it was replaced in 1914 by the larger brick school which became known as Meredith High School, and later the Humiston Building.

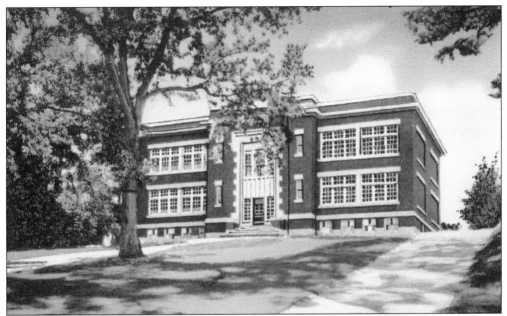

Meredith High School, 1914. This school was active until 1958, at which time a new facility was built, one mile north of the village on Route 25 East. Today, that new building is known as the Inter-Lakes Junior-Senior High School, and services the towns of Meredith, Center Harbor, and Sandwich, New Hampshire.

St. John's Seminary, 1920–30. Located on Route 25 East at the Meredith and Center Harbor town line, this summer camp was originally used for student priests. It is presently known as Patrician Shores.

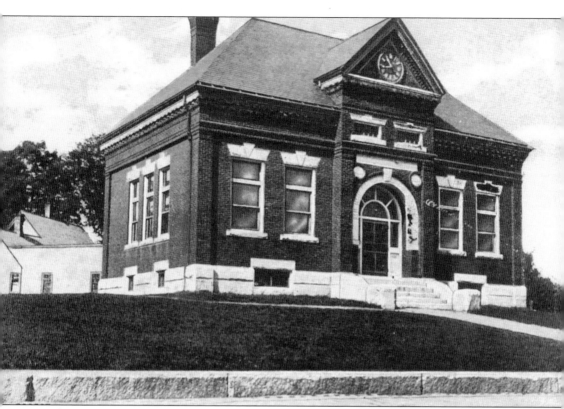

The Benjamin M. Smith Memorial Library. The library had its advent in the Dr. George Sanborn House at the corner of Main and Water Streets. Dr. Sanborn's son, George Freeman Sanborn, first operated a reading room adjacent to his *Meredith News* office in 1882. In 1885, the library books were moved down Main Street to the printing office of the new librarian, Clarance A. Clark, at the corner of Main and Lake Streets (the site of the old Meredith Town Hall). Across the street from C.A. Clark's library was the old Meredith House, which was later moved to make way for the Benjamin M. Smith Library.

After being closed for a few months in 1888, the Meredith Public Library reopened at Post Office Square, but this time in the Ladd Building, presently the Meredith Historical Museum. The library was located toward the rear of the building on the second floor. Patrons probably entered the building from the Highland Street side and walked up the back stairs.

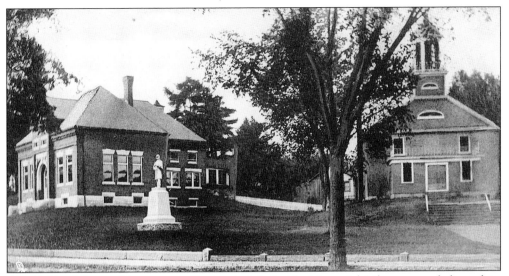

The Public Library. The present Benjamin M. Smith Memorial Library was dedicated in June 1901. On August 13, 1989, an new addition to the library was celebrated with a dedication and open house. Shown here are the library, Baptist church, and soldiers monument.

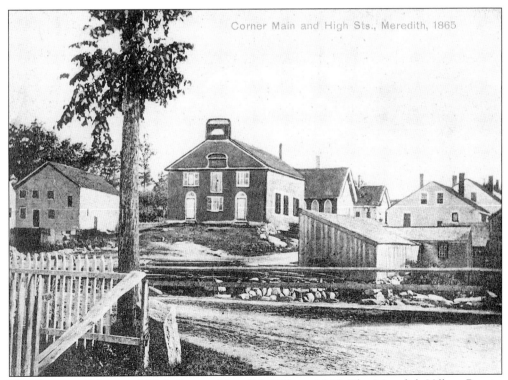

The Corner of Main and High Streets, Meredith Village, 1865. The Meredith Village Baptist Church is in the center, with the old Meredith House on the far left.

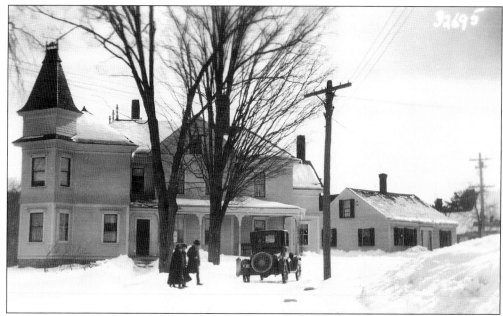

The Corner of South Main and Waukewan Street, Meredith Village, March 1944. Built for Dr. Fred L. Hawkins, today it is known to many as the Dr. Deneault, DD, Homestead.

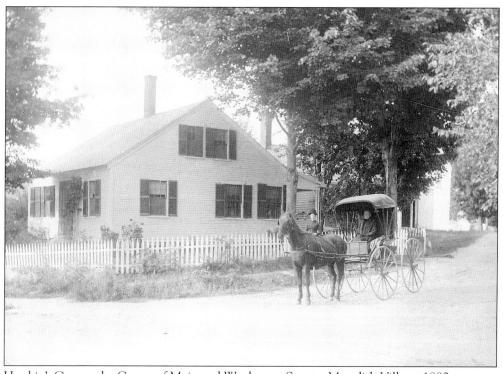

Hawkin's Corner, the Corner of Main and Waukewan Streets, Meredith Village, 1880s..

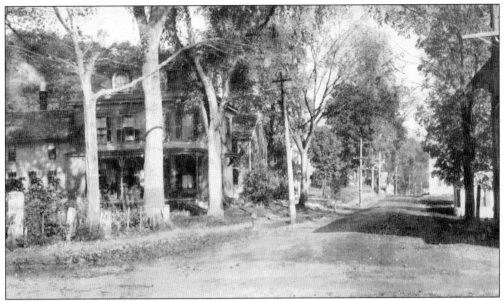

Plymouth Street, Meredith Village, before 1910. The first house on left is the present home of American Legion Post #33.

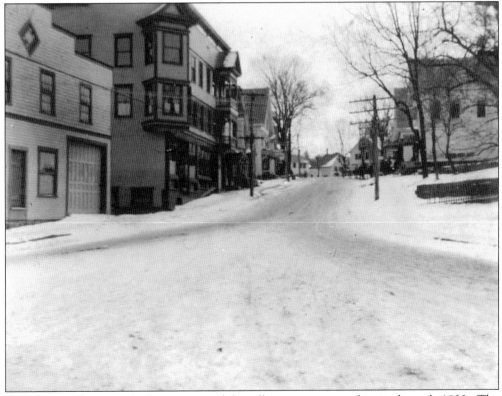

Main Street. This view, looking up toward the village proper, was taken in the early 1900s. The Horne Block is on the left.

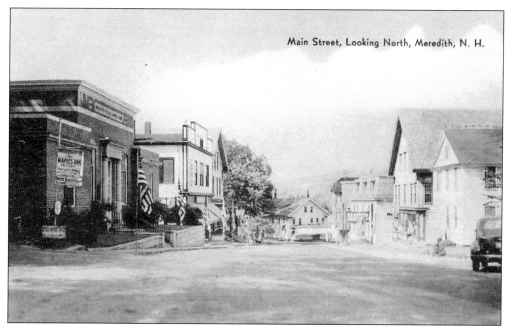

Main Street at Post Office Square (the Corner of Main and Highland Streets), Looking North, 1940s. The brick building on the left was the Meredith Village Savings Bank, now the Meredith Municipal Building.

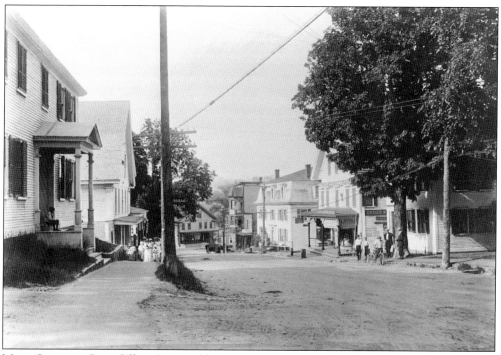

Main Street at Post Office Square (the Corner of Main and Highland Streets), Looking North, mid-1800s.

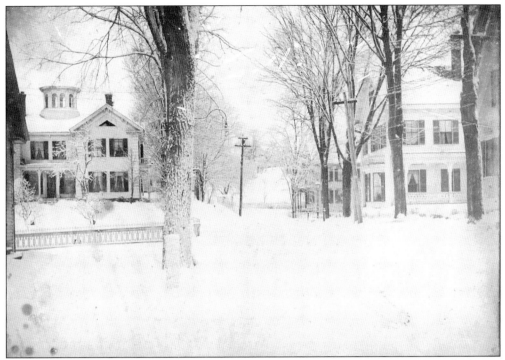

Highland Street from Post Office Square, Meredith Village, Winter of 1920. John Beede's house is to the left.

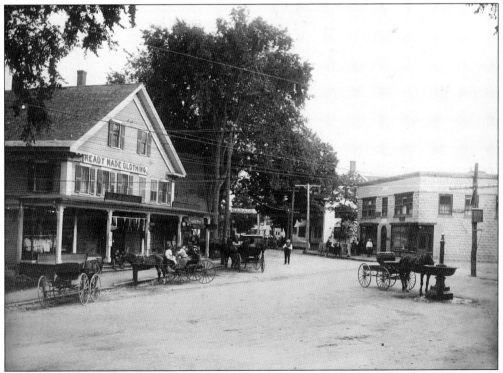

Main Street at Post Office Square, Looking South, *c*. 1880s. Hawkin's Block is on the right.

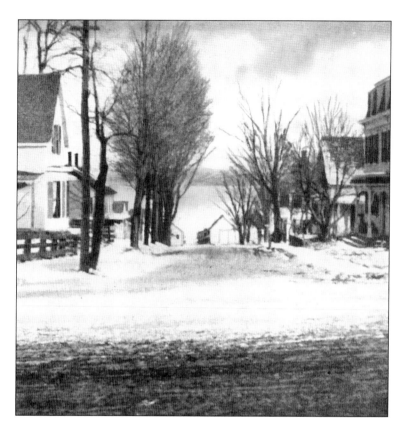

Lake Street in Winter, Looking toward Meredith Bay from Main Street, Meredith Village.

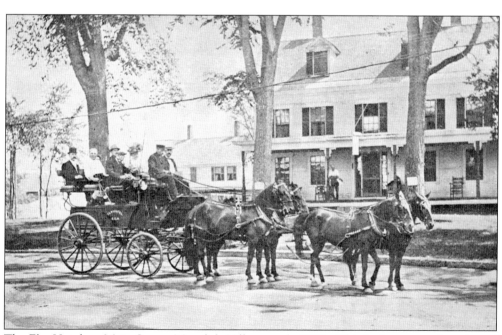

The Elm Hotel on Main Street, Meredith Village, early 1900s. This is the present location of the Meredith Post Office.

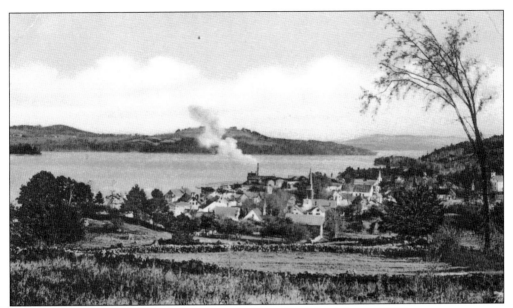

Meredith Village, Bay, and the Neck from the Top of Highland Street, 1880s.

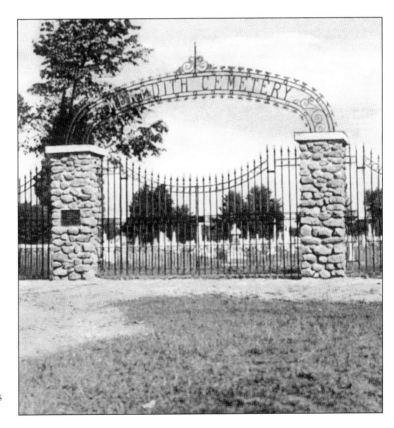

Meredith Cemetery. This gateway was erected in 1916 by Katherine Gilman, in memory of Charles Francis Gilman.

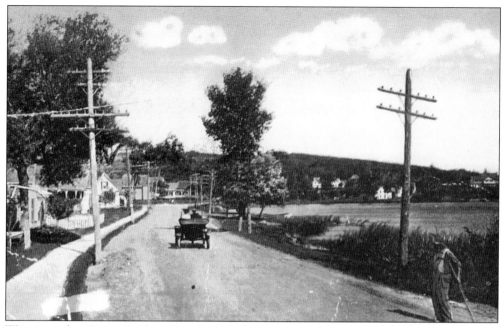
Winnipesaukee Street, Looking East from the Intersection of Routes 3 and 25 East.

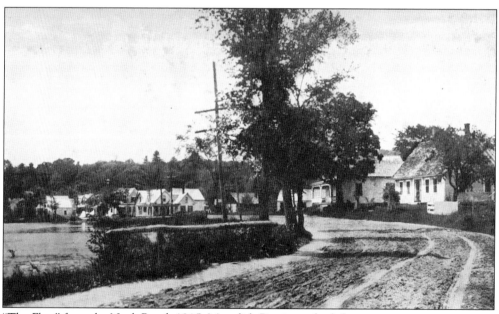
"The Flats" from the Neck Road, 1915. Meredith Bay is on the left.

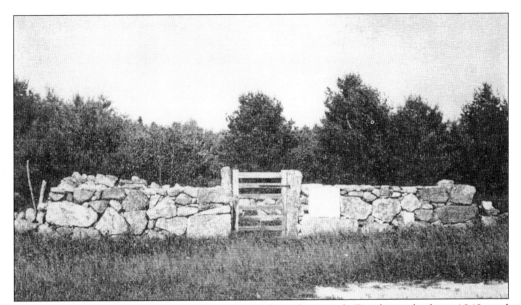

The Meredith Town Pound. The pound, located on the Parade Road, was built in 1848, and restored in 1934. These pounds can still be found scattered throughout the region. They are usually a rectangular (25-by-40 feet) corral, chest high, and made entirely of well-cut granite stone. The gates were either made of iron-hinged doors or a few boards held by a pole wedged against them. The location of the pound was just outside the village proper, but far enough away so as not to be a nuisance to the townspeople.

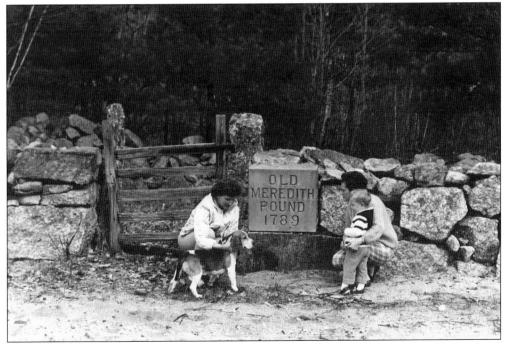

The Old Meredith Pound, 1789. Mrs. George D. Russell and friend "Wilbur" are shown here, while Mrs. Carl Chase Jr. and son investigate the "Lower Pound."

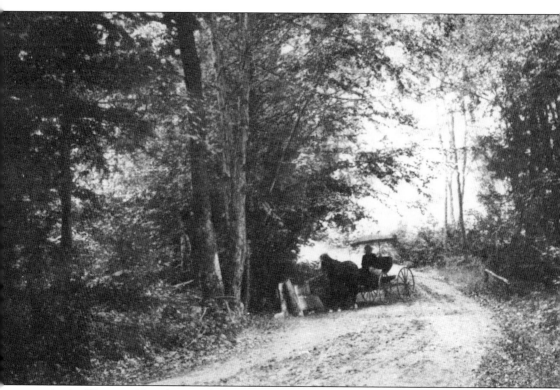

At the Watering Trough, Meredith Neck, mid-1800s.

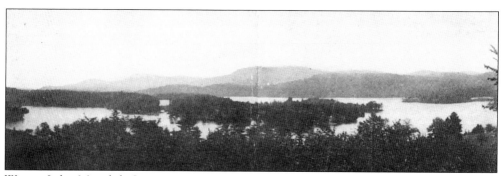

Wicwas Lake, Meredith Center.

Five

Transportation: Railroads and Boat Travel

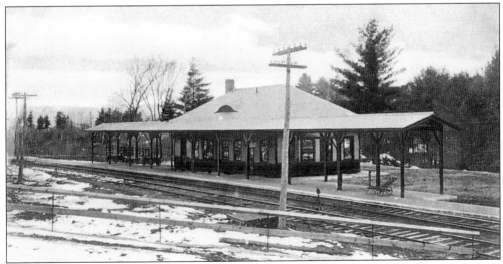

The Meredith Depot. In March 1845, the first survey was started for a railroad service through Meredith Bridge. This was the beginning of the most notable development in the history of the town. It was the cause of more industrial progress than any other single event. The Boston, Concord & Montreal Railroad reached Meredith Bridge in 1848. The construction of this railroad rapidly changed the existing conditions of the many towns on its route, and brought immediate distinction to the communities lying upon its line, including Meredith Bridge, Lake Village, and Meredith Village.

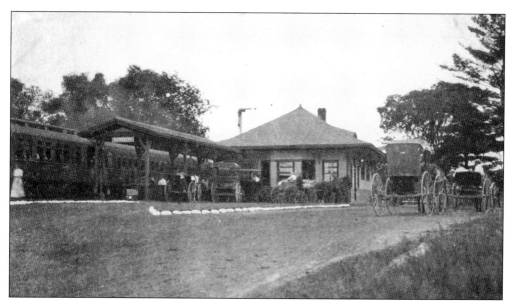

The Boston & Maine Railroad Station, Meredith, NH, early 1900s. When the railroad came to Meredith in 1848, it changed the complexion of the town for years to come. Over the rails came the coal that would power local steam engines, such as the one at the Meredith Linen Mills. Back down the tracks went shipments of Frank R. Prescott's wheelbarrows and coffins from the Meredith Casket factory. Approaching the tracks along South Main Street, the freight depot was on the left and the passenger station (shown here) on the right.

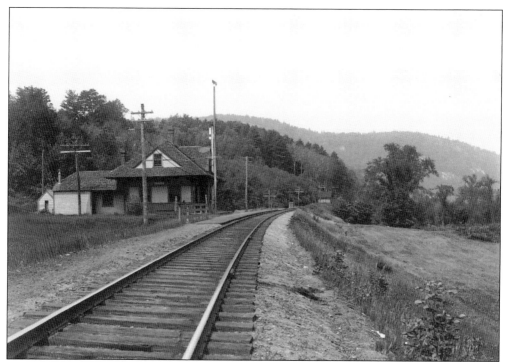

The Winona Railroad Station, before 1925. This was a very popular stop for travelers during the 1880s–1920s.

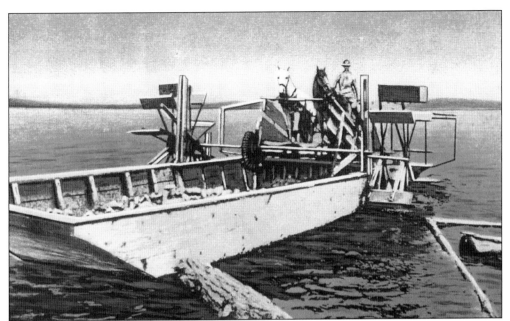

Lavallee's Horse Boat. This vessel operated on Lake Winnipesaukee from 1878 to 1890. The early boats used for transporting goods and people were barges (some were equipped with sails). The gundalow was used somewhat, and some lumber schooners were said to have been used. The horseboat, with the horse or horses activating the sidewheel paddles by means of a tread-mill, was also used. The first steamboat was the *Belknap*, which was launched on October 14, 1832, at Lake Village. This vessel was later wrecked in a storm while towing a raft of logs near what is now called Steamboat Island in Lake Winnipesaukee.

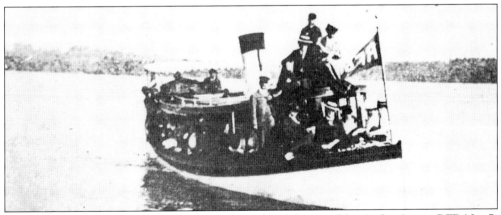

The *Dolphin*, One of the First Mail Boats, Owned and Operated by Archie Lewis. RFD No. 7, Laconia, New Hampshire—this was the address first established in 1892, when the first mail vessel was put upon Lake Winnipesaukee. In 1916, an act of Congress made this the only floating post office on an inland body of water in the United States. The original steamer used to transport mail was called the *Robert & Arthur*, built in 1892. The *Dolphin*, built in 1894, soon followed.

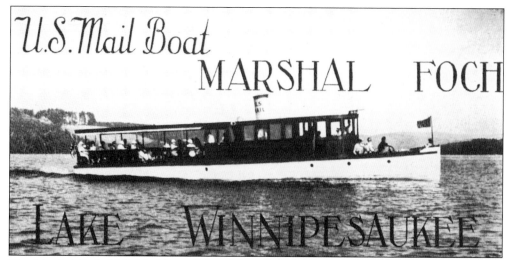

The *Marshal Foch*, U.S. Mail Boat, Edward Lavallee, Captain. During the years 1932–33, the mail was carried by the *Marshal Foch*, Captain Lavallee's personal boat, after the original *Uncle Sam* retired her claim to the mail franchise.

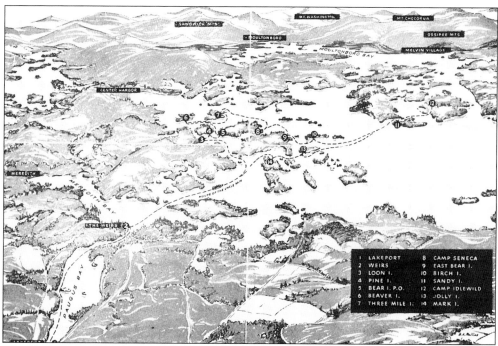

The *Uncle Sam* Map, Showing the Route of Mail Delivery.

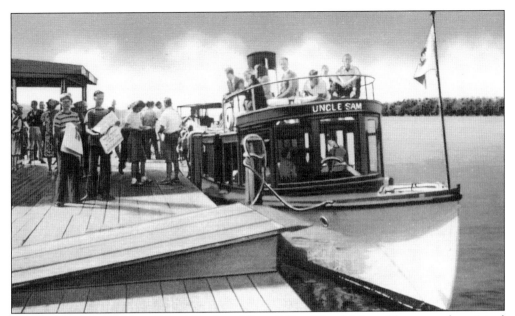

The *Uncle Sam* at the Bear Island Dock and Post Office. The third mail boat was the original *Uncle Sam*, built in 1906 for Mr. Seabury of Long Island, New York. The vessel was 65-feet long, had a 14-foot beam, drew 7 feet of water, was capable of carrying one hundred passengers, and was a single screw vessel. In 1945, this boat was converted from the traditional steam to the new diesel-type engine and kept her franchise on the lake until 1961, when she was retired.

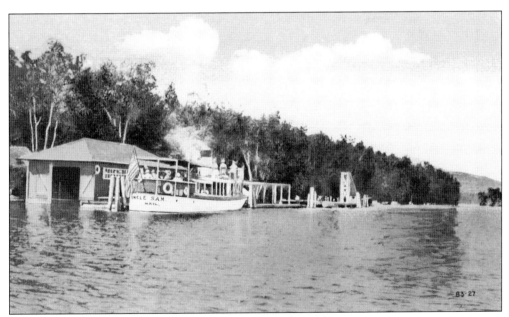

The *Uncle Sam* at the Three Mile Island Landing, Early 1930s.

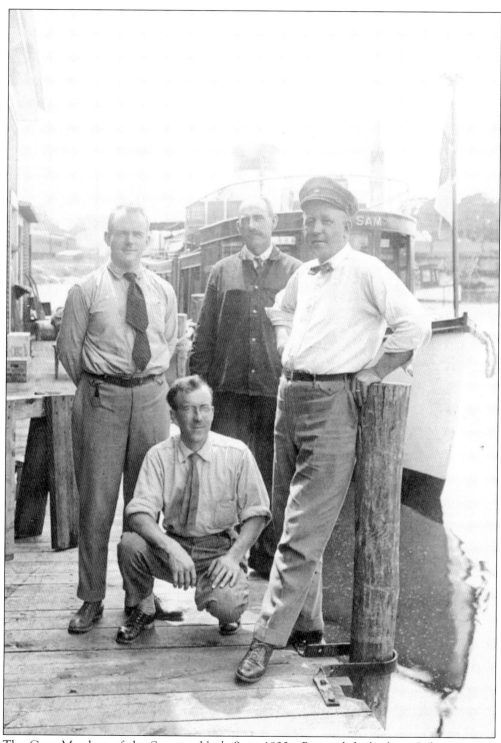

The Crew Members of the Steamer *Uncle Sam*, 1920s. Pictured dockside in Lakeport, NH, are: Archie Lewis (captain), Bert Bickford (fireman), Edmund Sawyer (mail clerk), and Clarence Hubbard (mail clerk).

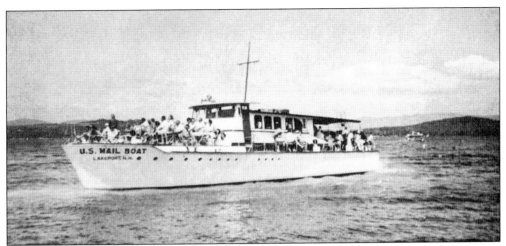

The *Uncle Sam II*. In 1962, the Uncle *Sam II* made her appearance on the lake, after a laborious overland travel from the Portsmouth Navy Yard. This vessel was a converted PT boat which was 72 feet long, with a 20-foot beam, drew 6 feet of water, weighed 80 tons, traveled at 15 miles an hour, and was capable of carrying one hundred and fifty passengers. On March 23, 1963, under the dual ownership of Vernon Cotton and Allan Perley, she slipped through the waters on her maiden voyage to serve the many islands in Winnipesaukee. Postmaster Ed Lavallee prepared the mail, luggage, etc., right on board, thus giving it the continuing distinction of being a floating post office.

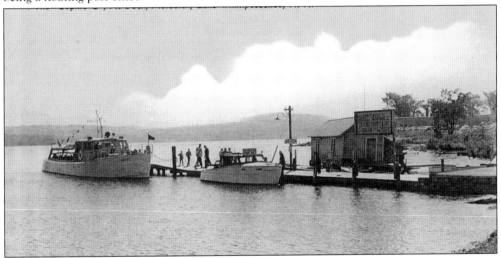

The *Sophie* C at the Dock in Meredith, Robert Murphy, Captain, mid-1940s. In 1969, the mail franchise was placed with the *Sophie* C. This vessel was built by the General Ship and Engine Works of East Boston, Massachusetts, and was launched at Center Harbor, NH, in August 1945, for the sole purpose of being a shuttle service between Wolfeborough and the Weirs, while the area awaited the recommissioning of the *Mount Washington*. The vessel is fitted with a diesel engine and is capable of traveling 15 miles per hour. It is 76 feet long, with a 16-foot beam, has a capacity of one hundred and twenty-five passengers, is built entirely of steel, and is fully fireproof. When the craft was commissioned, it was christened *Sophie* C after the owner's mother. This vessel, like her predecessors, services the many islands in Meredith Township. It is presently owned by the Winnipesaukee Flagship Corporation, in Weirs Beach and Meredith, New Hampshire.

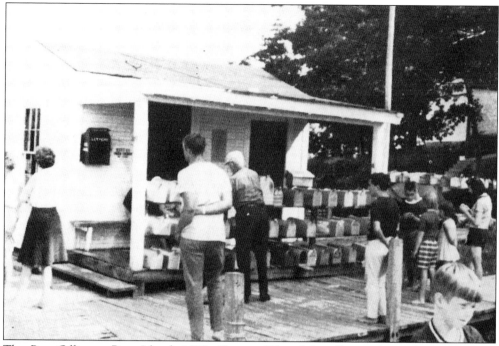

The Post Office at Bear Island, 1970. Captain Edward Lavallee is shown here delivering the daily mail.

The Three Mile Island Recreation Building, 1970. This is one of the many stops made by the mail boat.

Captain Wilbur Bigelow, 1970. There is a great deal of wildlife on the islands, which sometimes come down to the dock to meet Captain Wilbur during his daily mail delivery

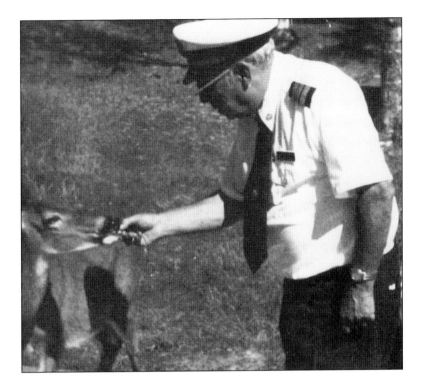

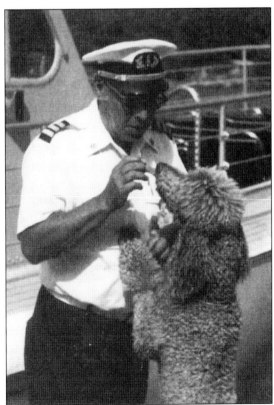

Island Dogs, 1970. The island dogs can always be found at the dock when the *Sophie C* arrives, waiting for their daily treat from Captain Bigelow.

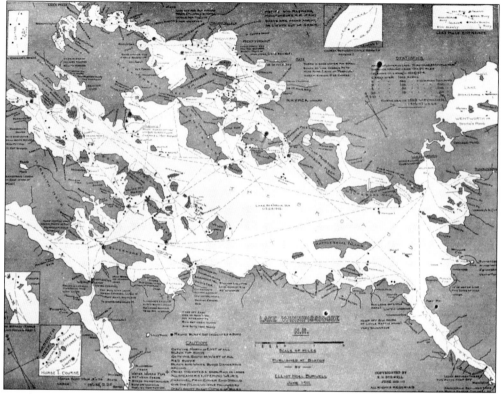

A Lake Winnipesaukee Map, June 1911.

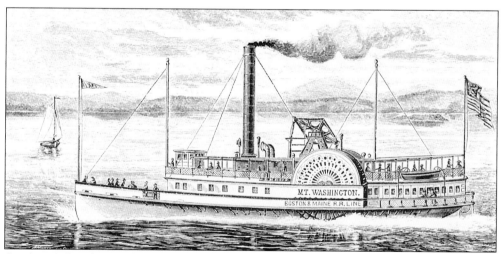

An Artist's Rendition of the Steamer *Mount Washington*, 1890s. As transportation improved, the railroad companies built their rails and constructed their boats to accommodate the growing need for mass travel throughout the Lakes Region. The most famous of these boats was the side-wheeler *Mount Washington*, launched in 1872. When the first trip was made, it was the largest of the lake steamers and served for many years to carry thousands of passengers over the 65-mile route around the lake. This vessel passed through several owners, and finally burned at its berth at the Weirs.

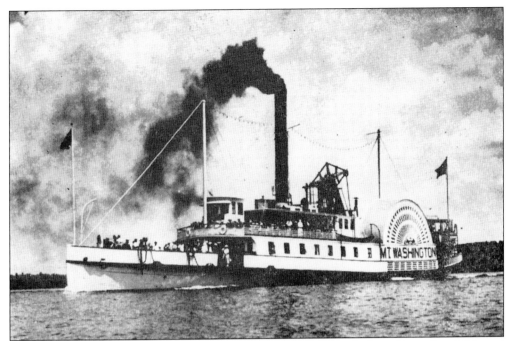

The Steamer *Mount Washington*. In 1872, this vessel was launched at Alton Bay, NH, and christened the *Mount Washington*. She was longest, fastest, and considered the most beautiful side-wheeler ever built in the United States. A single piston with a diameter of 42 inches and a stroke of 10 feet drove this vessel at better than 20 miles per hour. The piston drove these side wheels by means of a walking beam on top of the superstructure. The horsepower was 450 at full ahead, more than enough to leave any of her competition in her wake.

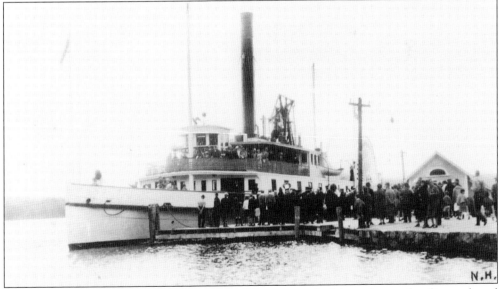

The Steamer *Mount Washington*, Early 1930s. "Here comes the *Mount*," was a familiar cry heard on the shore of Lake Winnipesaukee. When it rang, down along the shore, ladies left their knitting on the porch, youngsters ran for the pier, bathers stopped to watch her steaming by, and canoes and speed boats swung "round to catch her wave."

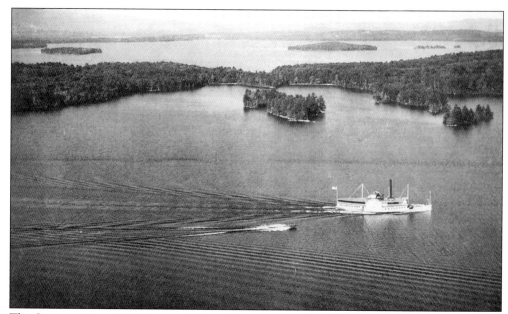

The Steamer *Mount Washington*, 1930s. This is an aerial view of the *Mount* with Bear Island (Indian Carry) in the background.

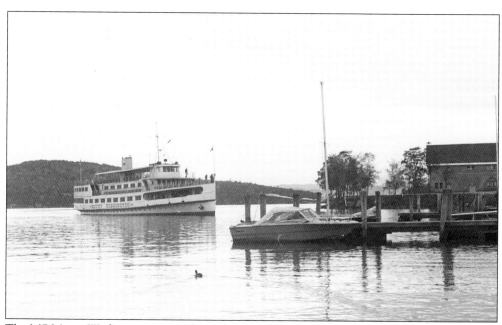

The MS *Mount Washington* Approaching the Meredith Town Docks, October 1986.

Six

Reflections of Yesterday

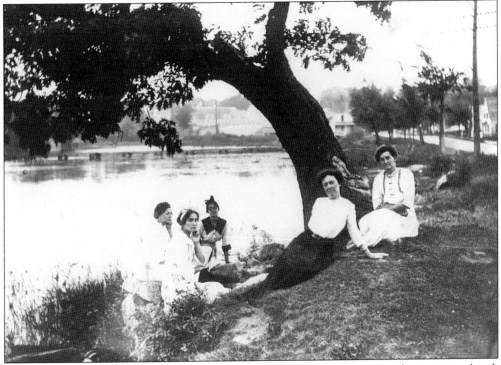

Under the Old Oak, 1915. Over these many years, memories of past events have accumulated, and many changes have taken place which have altered the physical appearance of our villages and general landscapes of the town. In this chapter we shall recall those bygone days through a photographic potpourri of the events and people who are a part of the heritage of Meredith, New Hampshire. This photograph shows Mrs. Eaton and friends from Massachusetts relaxing under the Old Oak on the shore of Meredith Bay.

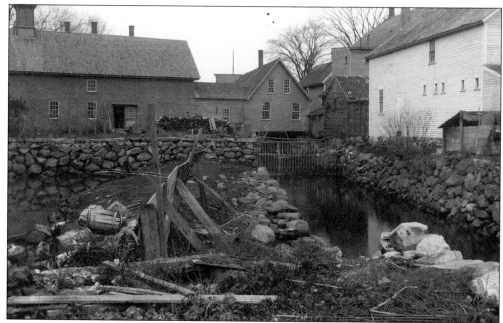

The Canal, West of a Main Street Store, Meredith Village, November 1903.

John Fifield Cleaning Debris from the Water Gates, April 17, 1906. The George Hoyt House can be seen in the background.

The Future Weeks & Smith General Store, Water Street, Meredith Village.

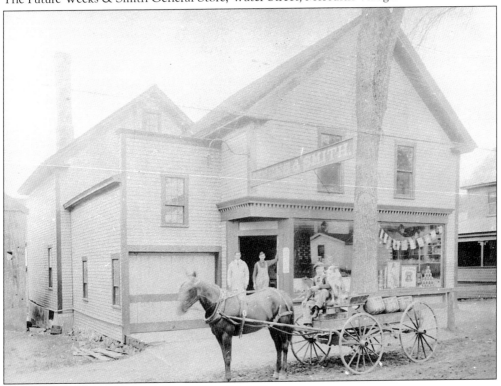

The Weeks & Smith General Store, Meredith Village.

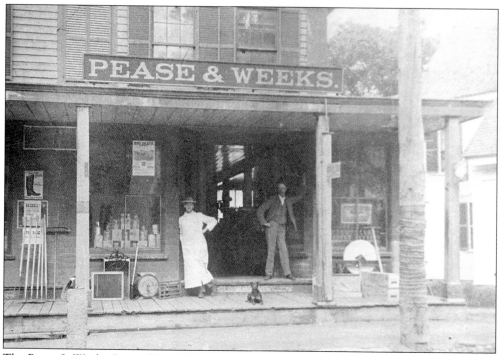

The Pease & Weeks General Store, Main Street, Meredith Village, 1903–1907.

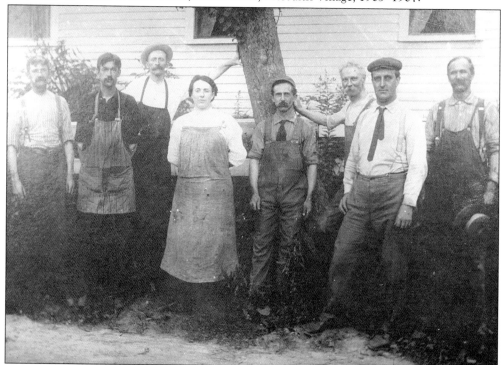

The Crew at the Meredith Casket Company. Included in this image are Frank Bartlett, Marie Ricket, William Walker, Wilbur Emery, and Saul Willey. Chase's Country Towne House Restaurant is presently located on this property.

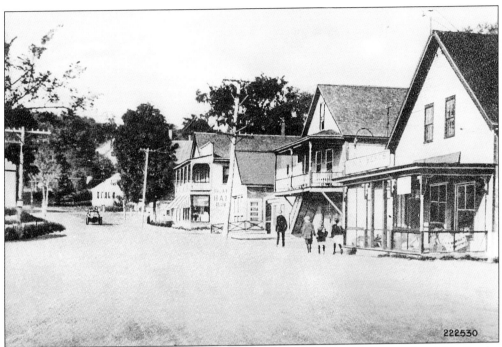

Winnipesaukee Street. This is now the location of the intersection of Routes 3 and 25. On the right, some buildings have been removed and Route 25 swings west towards Plymouth. The auto shown in background is coming down from Main Street in Meredith Village.

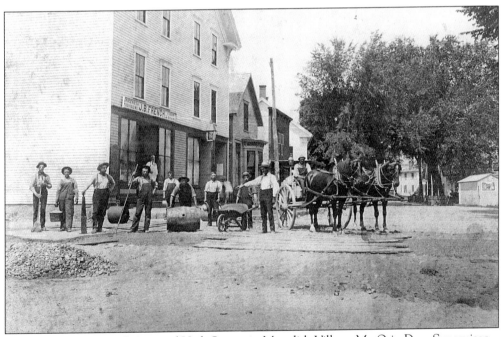

Paving at the Corner of Main and High Streets in Meredith Village, Mr. Orin Dow, Supervisor.

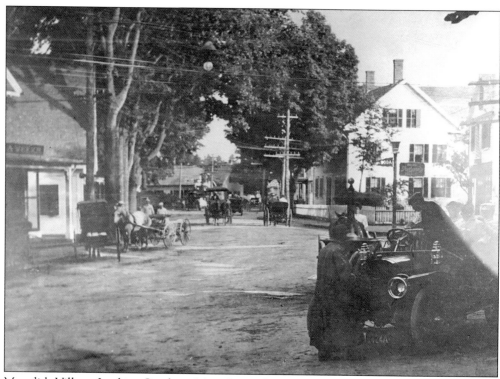

Meredith Village, Looking South on Main Street from Post Office Square, 1907.

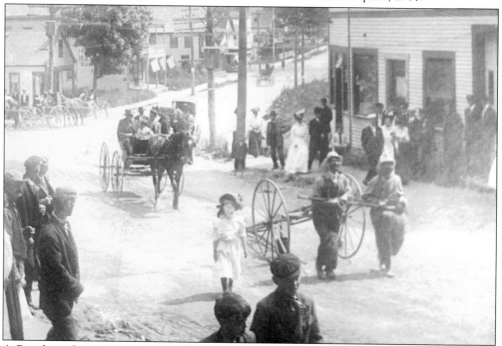

A Parade on Lower Main Street. The occasion for this celebration was the turning on of the water system. The Horne Block on the right. Note the homes in the background on the left side of the street (Winnipesaukee Street)—there is no intersection or traffic light.

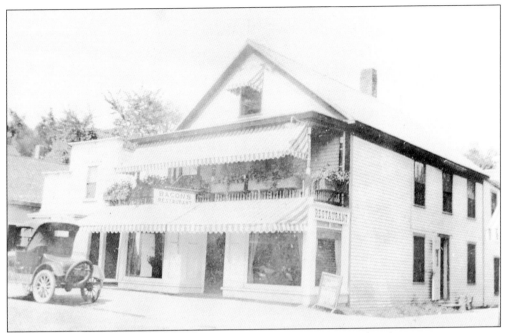

Bacon's Restaurant, the Intersection of Routes 3 and 25, Winnipesaukee Street.

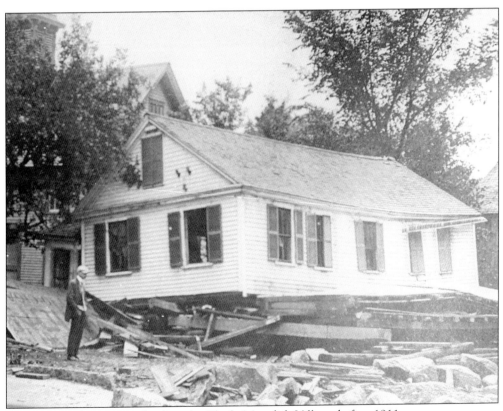

Preparing for the Present-day Samaha Block, Meredith Village, before 1911.

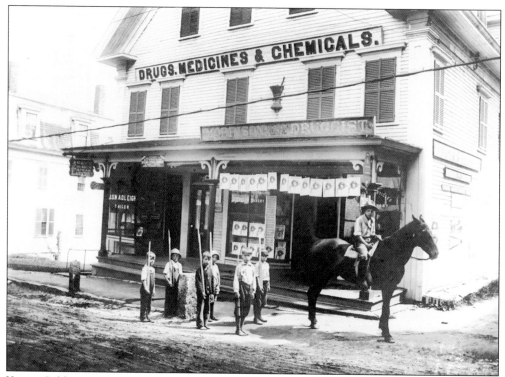

Young Soldiers on Lower Main Street. This group of "soldiers" pose in front of Morrison's Drugstore, later known as the IOOF Hall.

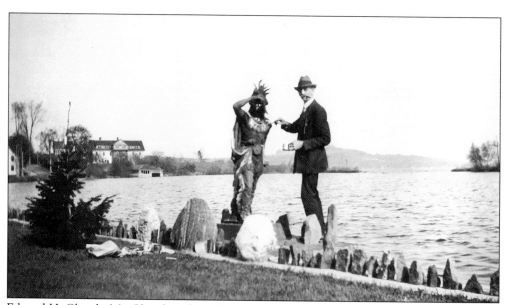

Edward H. Clough. Mr. Clough is shown here cleaning the statue of Hiawatha at Clough Park on the shore of Meredith Bay. In the background on the left, the Hattie Moses School can be seen.

The New Hampshire State Fair at Meredith Bridge, from *Gleason's Pictorial*, October 30, 1852.

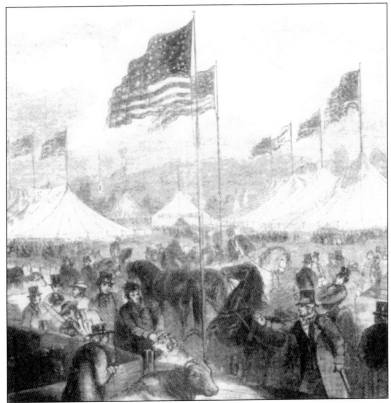

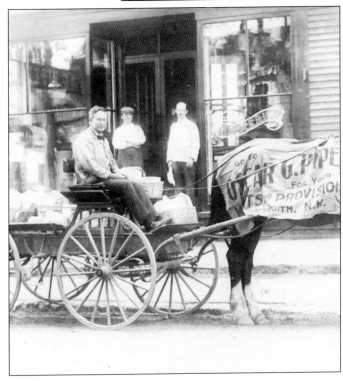

Harvey Fogg Advertising in front of Piper's Marker, Corner of Main and High Streets, Meredith Village.

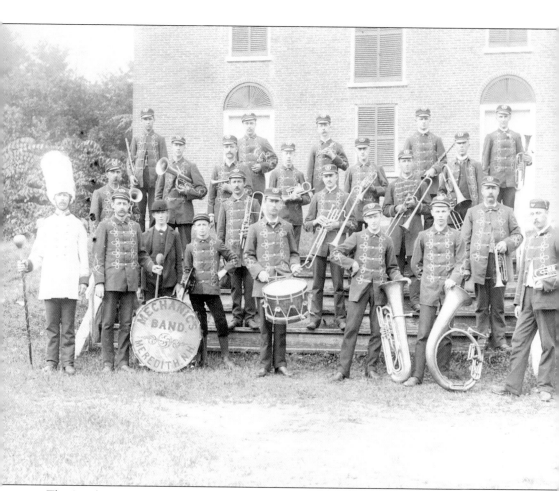

The Mechanics Band, after 1885. This band was under the direction of David A. Vittum. From left to right are: (front row) John Kendrick, Sid Baker, Charles Berry, Herman Dow, Harry Dow, H.V. Jones, Ira St. Clair, Arthur Simmons, David Parsons, Lewis James, Bert James, Fred Niles, Harry James, Lorin S. Pease, David Parsons, Harry Kendrick, James Leighton, and Arthur Vittum; (back row) Charles St. Clair, Elmer Kendrick, Fred Wilson, John St. Clair, and George Grant.

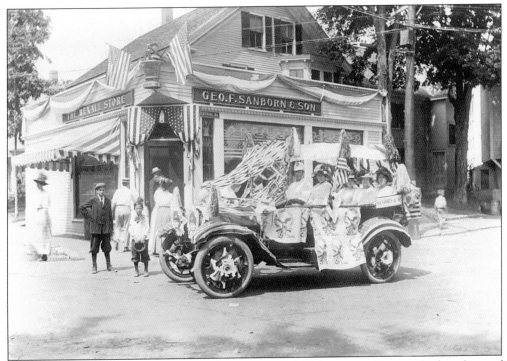

The First Prize Float, Fourth of July Parade, 1915. This float was photographed in front of Geo. F. Sanborn's drug store on the corner of Main and Water Streets, Meredith Village.

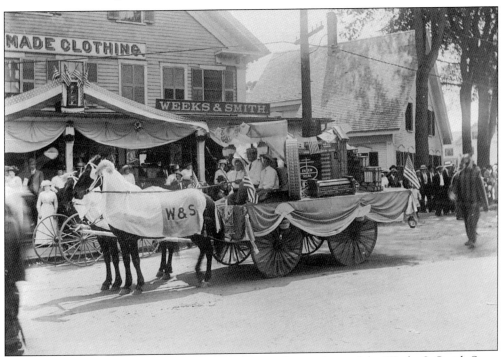

A Float, Fourth of July, 1915. This photograph was taken in front of the Weeks & Smith Store on Main Street in Post Office Square, Meredith Village.

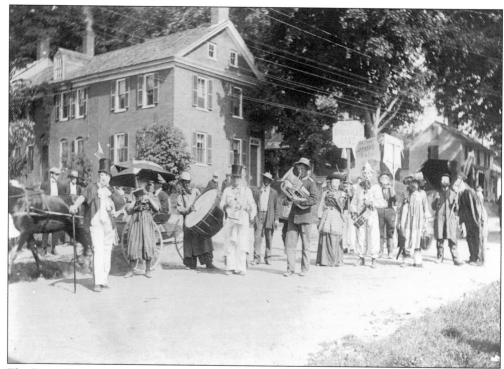

The Bingville Band on Plymouth Street, Meredith Village, before 1925.

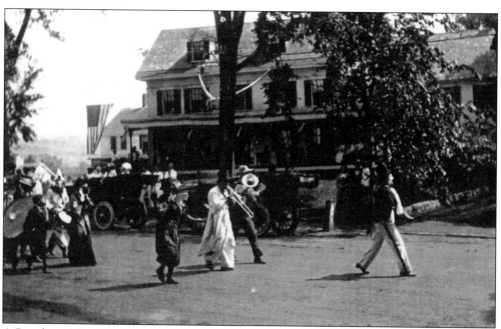

A Parade on Main Street, in front of the Elm Hotel, Meredith Village, Early 1900s.

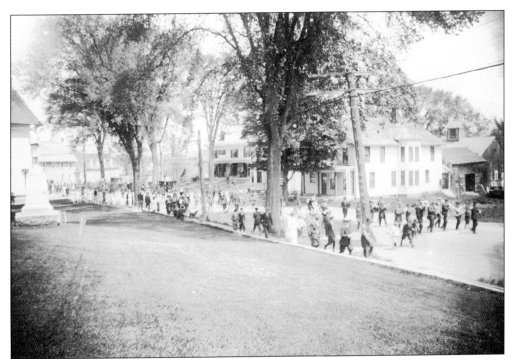

A Parade on Main Street, Meredith Village, *c.* 1919. This picture was taken from the knoll in front of present public library.

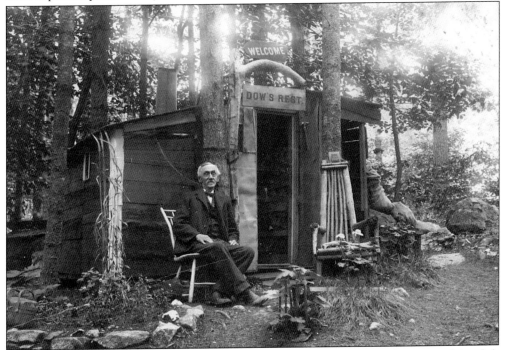

"Dow's Rest." Orin Frank Dow built this second camp in the woods on High Street in Meredith Village so as to be near his family, but not live with them. He had many visitors and kept a guest book with more than two thousand names.

Wicwas Lake Grange Hall, Meredith Center, 1901. The land for this building was deeded by Warren Kimball to the Grange so they could have a proper meeting hall for their farm organization. The building was rebuilt in 1930.

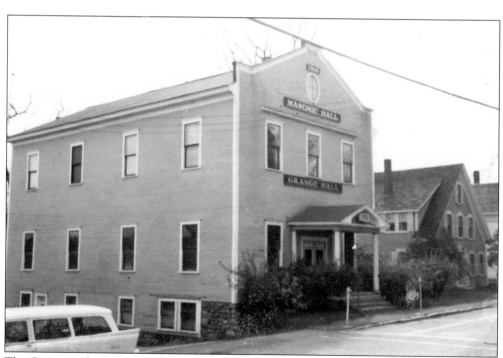

The Grange and Masonic Halls on Main Street, Meredith Village, 1914.

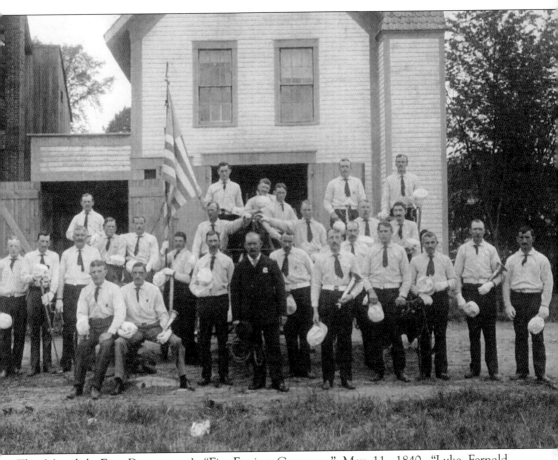

The Meredith Fire Department's "Fire-Engine Company," May 11, 1840. "Luke Fernald, Joseph Dodge, David Corlis, Jr., Nathaniel G. Corliss and John Busiel have given notice that we and our associates have formed ourselves into a company, to be known by the name of the First Fire-Engine Company in Meredith village, agreeably to an act of the Legislature of New Hampshire, passed July 1, 1831, A. B. Merrick, Clerk." Before 1895, a two-story wooden building, located in Corporation Square, was used as the town's first fire station. The men in the center are leaning on "the Wamesit," the department's first piece of fire-fighting equipment, a hand tub acquired from the City of Lowell, Massachusetts. In 1859, a group of fifty men formed the original fire company, known as the "Wamesit Company." They worked and saved until they could acquire a second-hand Hunneman Hand Tub fire pump from Lowell, MA. The department grew until 1895, when the hand tub was put into semi-retirement and two hose carriages were put into service. The first uniforms for the Meredith firemen were adopted in 1897. Meredith's first motorized fire truck was a custom-built 1929 Ford Model A. This vehicle carried hoses, ladders, and portable pumps, but did not have a built-in pump. Through the years the department has become one of the finest fire departments in the state.

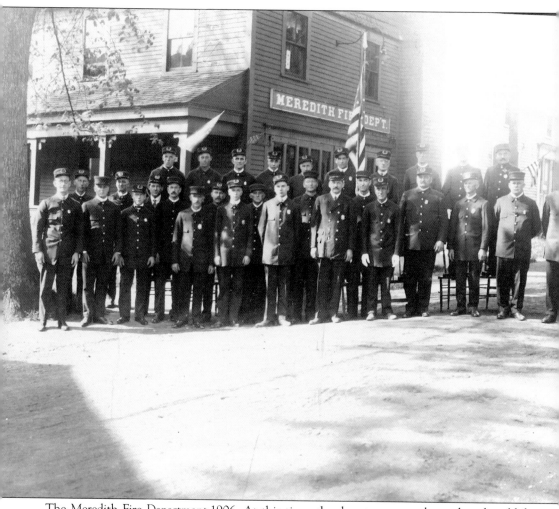

The Meredith Fire Department, 1906. At this time, the department was located at the old fire station on Water Street. Presently, this is the site of a parking lot across from *The Meredith News*.

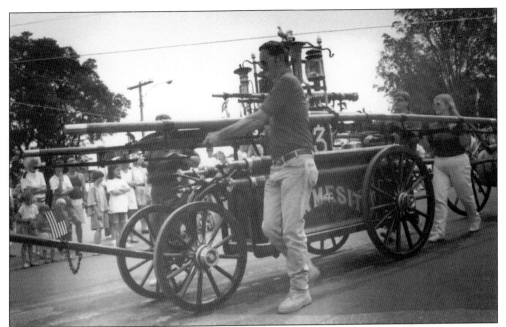

The Old Wamesit Hand Tub in a Parade on Main Street, *c.* 1980s. This particular piece of equipment was acquired in 1859 from Lowell, Massachusetts, and is owned by the Wamesit Company. It is presently housed in the Meredith Center Fire Station. Shown here are: Carl Smith (center forward), Jan Plancon and Christopher Plancon (far right in rear of hand tub), and Jay Haines (in back of hand tub).

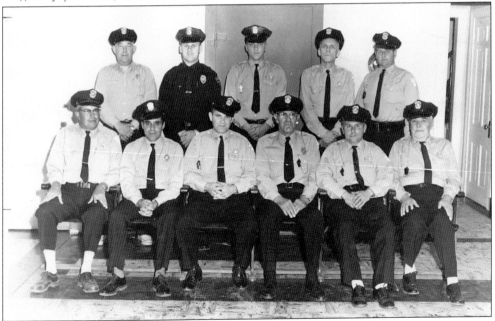

The Meredith Police Auxiliary, 1958. Pictured are, from left to right: (front row) Sgt. Del Dunn, Lt. Edward Greemore, Capt. Robert Bennett, Carl Smith, Lt. Perley Valliere, and Steril Trainor; (back row) Chief Norman (Buster) Martin, Herb Horne, Roy Larson, Sgt. Sherman Weaver, and Lt. Richard Beede.

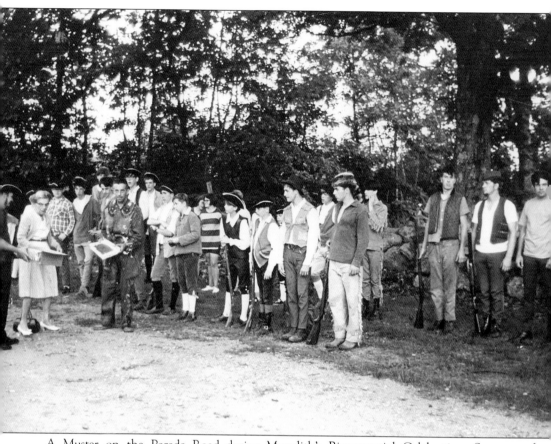

A Muster on the Parade Road during Meredith's Bicentennial Celebration, Summer of 1968. Pictured are, from left to right: Pvt. David Lawton, Lt. Col. Gordon Whitcher, Mrs. Helen Pynn, Pvt. John McGuigore, Pvt. Greg Olsen, Lt. Robert Beede, Sgt. Paul Dunleavy, Capt. Jack Dunleavy, Pvt. Steve Curtis, Pvt. George Copp, Pvt. Brian Hurd, Pvt. Chris Hurd, Nurse Marie Valliere, Nurse Betty Valliere, Pvt. Raymond Montana, Pvt. Charles Lowth, Pvt. Glen Mitchell, Pvt. Chris McCue, Pvt. William Prescott, Pvt. Craig Heald, Pvt. Peter Currier, Pvt. Robert White, Lt. Douglas Beede, and Pvt. Annie Paquette.

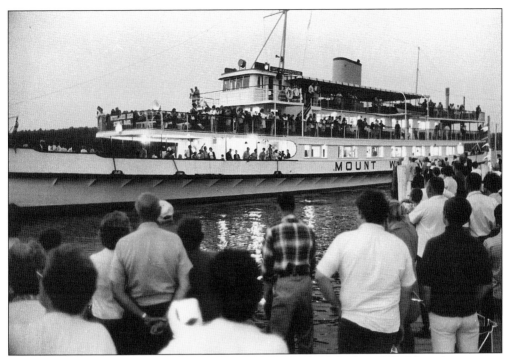

The MV *Mount Washington* at the Meredith Town Docks, July 31, 1968. Here the majestic *Mount* is shown, celebrating the Meredith bicentennial. The Inter-Lakes Concert Band is on the second deck forward performing for an estimated two thousand spectators. Captain Bryan Avery and Captain Robert Murphy are at the helm.

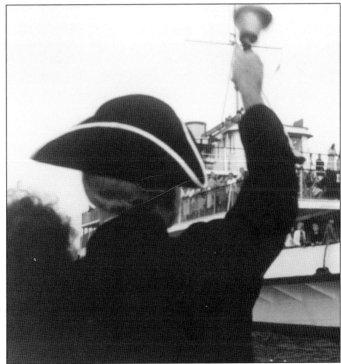

Meredith's Town Crier Greets the *Mount* at the Meredith Docks during the Bicentennial Celebration, July 31, 1968.

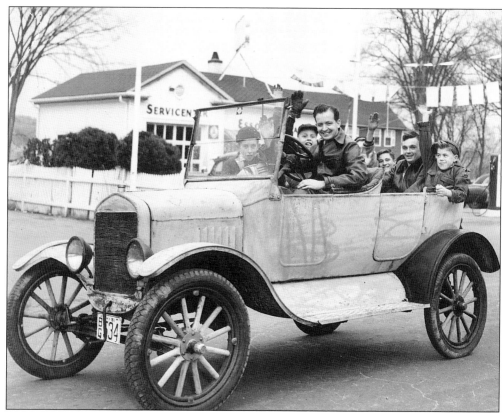

Bob Montana. The creator of Archie Comic is shown here, with the "Plymouth Street Gang," riding down Main Street in the "Archie" mobile.

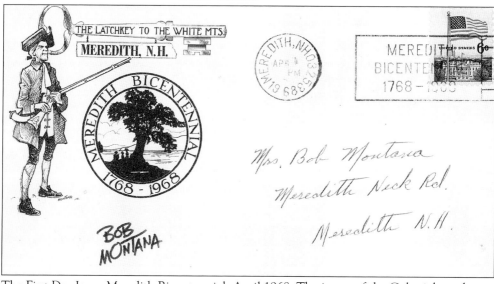

The First Day Issue, Meredith Bicentennial, April 1968. The image of the Colonial gentleman was created by artist Bob Montana and is personally signed by him. The "Latchkey to the White Mountains" was designed by Mrs. Marjory Bacon and the town seal–the "Old Oak"–was designed by Ruth Beede.

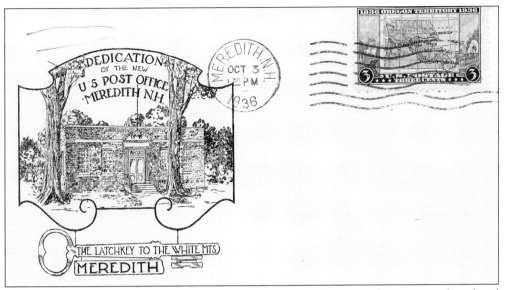

The Dedication of the New U. S. Post Office, Meredith, NH. This post card is dated October 3, 1936.

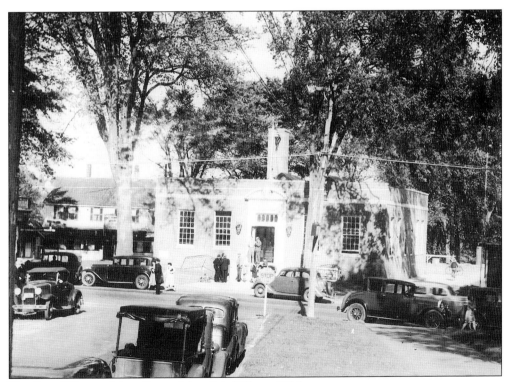

The Post Office on Main Street, Meredith Village, 1935.

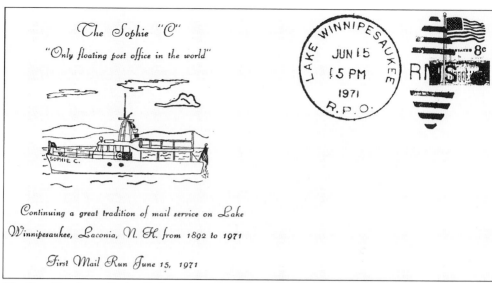

The First Day Issue, *Sophie C*, June 15, 1971. The cover was designed by Hector L. Bolduc.

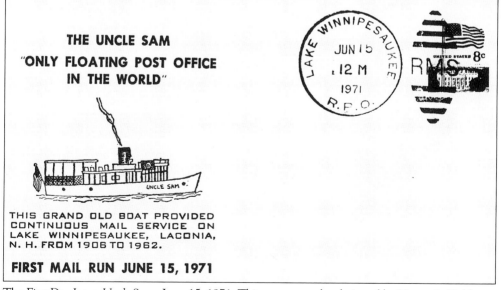

The First Day Issue, *Uncle Sam* , June 15, 1971. This cover was also designed by Hector L. Bolduc.

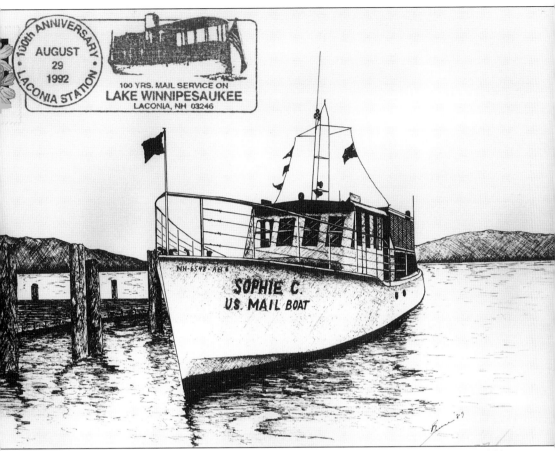

A *Sophie* C cancellation Stamp Celebrating the 100th Anniversary of Mail Service, August 29, 1992. The cancellation and pen-and-ink were designed by Bruce D. Heald.

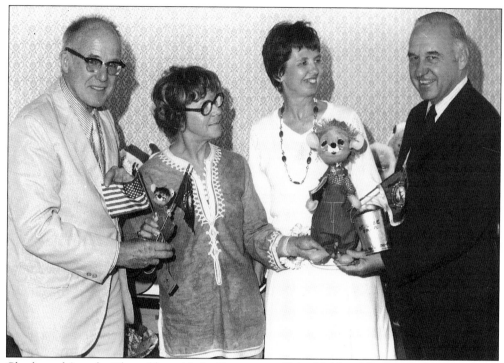

Charles and Annalee Thorndike, with the Governor and Mrs. Meldrim Thomson. This photograph was taken during Governor Thomson's visit to the Annalee Doll Factory in Meredith.

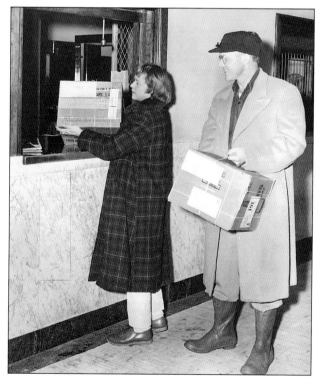

Annalee and Charles Thorndike at the Meredith Post Office. Annalee is mailing out some early creations of their Annalee Dolls to Sax Fifth Avenue in New York City.

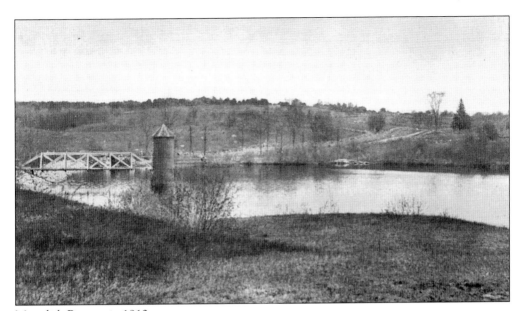

Meredith Reservoir, 1912.

The Lake Waukewan Bath Houses, Meredith Town Beach, 1907.

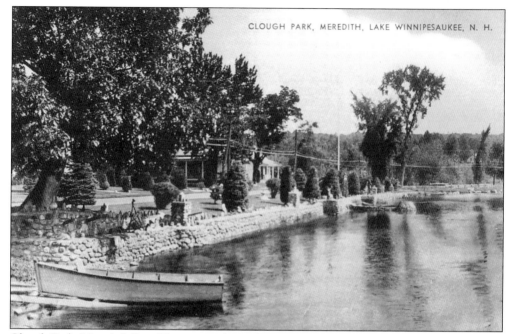

CLOUGH PARK, MEREDITH, LAKE WINNIPESAUKEE, N. H.

Clough Park, Meredith Bay. This image shows the view looking east on Winnipesaukee Street. The rocks that make up the wall were collected or donated from all over the world.

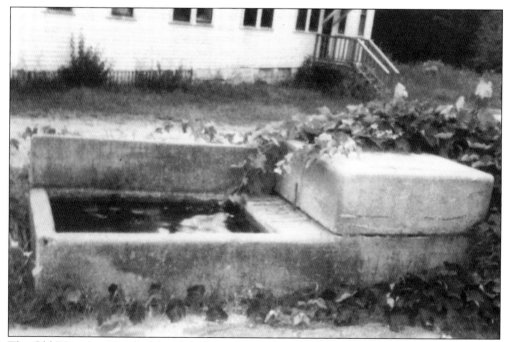

The Old Watering Trough, Meredith Center.

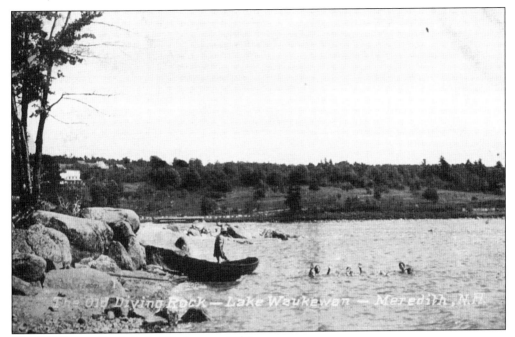

The Old Diving Rock, Lake Waukewan, 1930s.

Lake Waukewan, Outlet to the Canal.

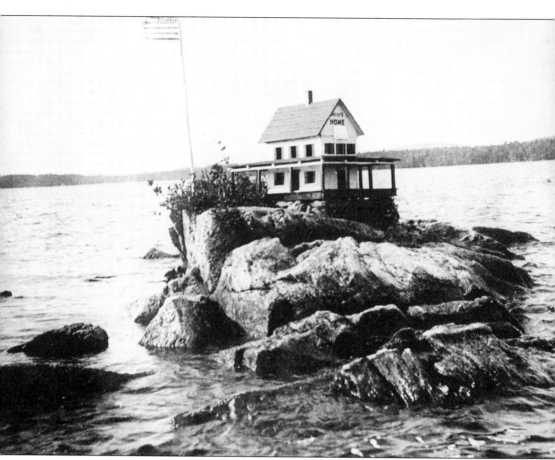

Becky's Garden (the Kelley House). This is the smallest charted island in Lake Winnipesaukee. The legend of Becky's Garden has it that an early settler of Center Harbor had several daughters, the loveliest of whom was named Rebecca. While her sisters were frivolous and spoiled, Rebecca was a model young lady who beautified the surroundings of her father's home by taking care of a garden. One day her father's cattle escaped and laid waste the beautiful garden plot. Rebecca was heartbroken, so her father, by way of consolation, offered her the gift of any one of the numerous islands in the lake which she might care to choose. Her sisters clamored for the same dowry, and their father finally consented, giving Becky first choice. This caused her sisters to be so envious that Becky decided to choose the smallest island she could find and selected the one which bears her name today, an island that is scarcely more than a brush-covered rock. The other daughters picked out large, verdant islands. The story of Becky's choice traveled far, and a wealthy young farmer in the vicinity became so interested when he heard of the unselfish young maiden that he sought her acquaintance. Finding her an attractive young lady, he wooed and won her for his bride. Thus it is said that Becky's Garden, though the smallest of islands, produced the greatest result.

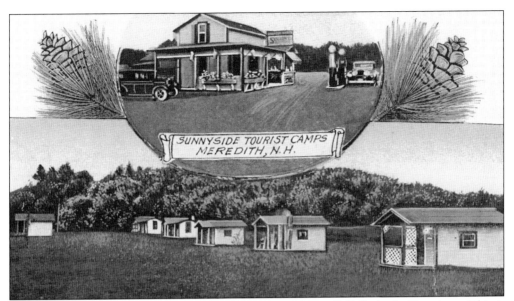

The Sunny Side Tourist Camp on Daniel Webster Highway, R.P. Peabody, Proprietor. This is presently the site of Scandia Park, across from Meredith Cemetery.

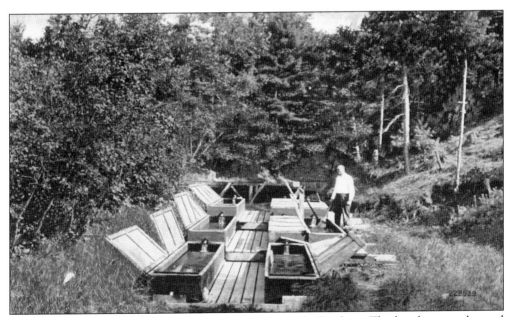

The Meredith and Lake Winnipesaukee Association Fish Hatchery. The hatchery was located on Hawkins Brook between Circle Drive and Prescott Park.

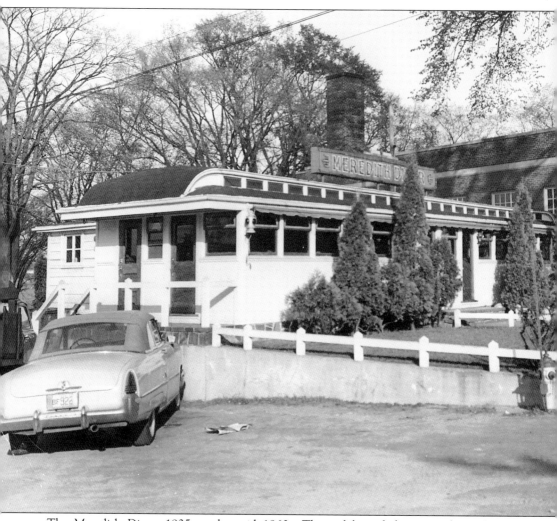

The Meredith Diner, 1935 to the mid–1960s. This celebrated diner was located on Main Street in the village next to the Meredith Post Office. It was owned and operated by Carl and Marion Chase, and was a popular gathering place and social magnet for the townspeople of the community. It was not uncommon to find the place filled beyond capacity after school basketball games, dances, concerts, plays, and Friday and Saturday night socials. They were best known for their fine food and hospitality. It should be noted that this diner was a vintage Worcester Diner from Worcester, Massachusetts.

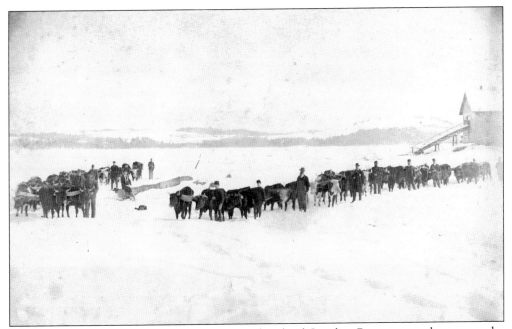

The Old Town Team on Meredith Bay, 1880s. The Shook Lumber Company can be seen on the right. This team was used to break roads throughout the town.

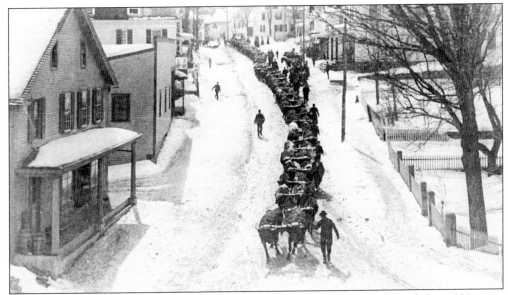

The 1881 Oxen Parade. This is a copy of Warren Ward's photograph of the 1881 oxen parade coming down the hill on Main Street, Meredith Village, toward the intersection of Routes 25 and 3.

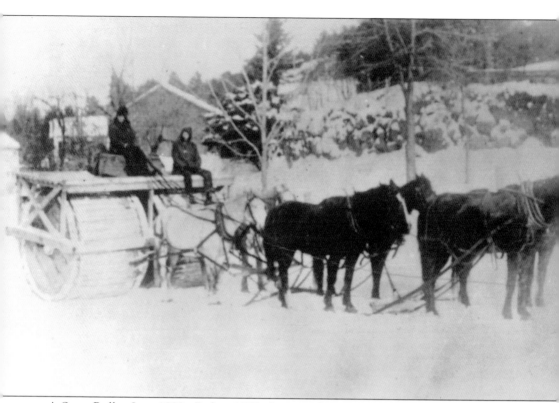

A Snow Roller, Late 1800s. Before 1927, the snow from the town roads was not removed, but rather packed down by a snow roller. This was simply a large roll made by placing planks on two steel wheels. Two sections were arranged on a single axle with a pole between the sections for the team of horses. A small platform was built on the top for the driver and his helper, along with a place to carry the necessary cider jug.

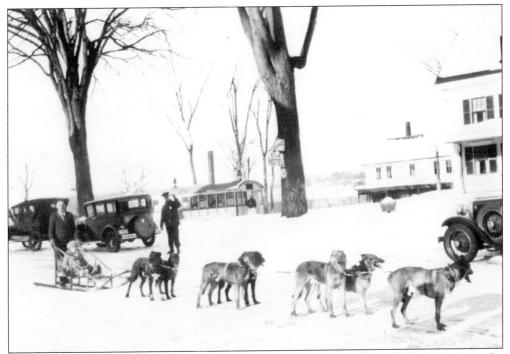

A Dog Team for the Winter Carnival on Main Street, Meredith Village, 1925. Al Ricker is the driver in this winter scene. The Meredith Diner and the Elm Hotel can be seen in the background.

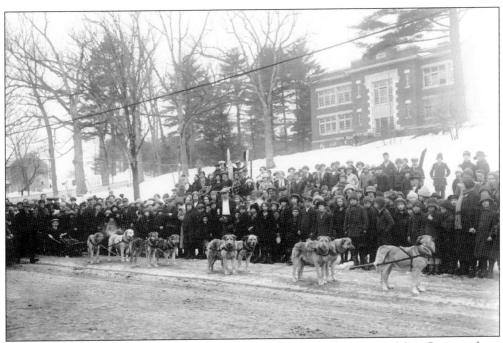

Arthur Walden's Dog Team, 1922–23. This photograph shows the team on Main Street in front of old Meredith High School. Mr. Walden and his lead dog, Chinook, became famous for their 1928 expedition with Admiral Richard E. Byrd to the Antarctic.

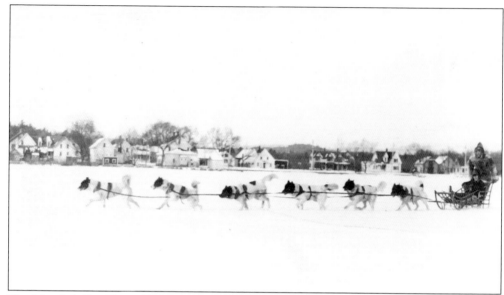

The Meredith Dog Team, Winter Carnival on Meredith Bay, 1925. Percy (Percival) Estes is the driver. Since the first dog sled races in 1923–24, this sport has become a very popular feature in the region. For a number of years, the Town of Meredith had its own team of sled dogs for its annual winter carnival.

Ipar, the lead dog for the town team, 1925.

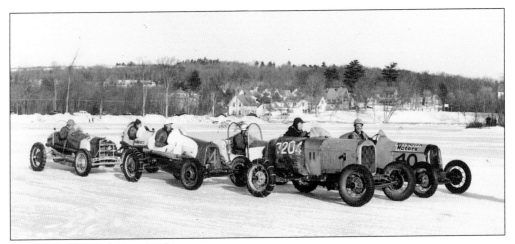

Racing on Meredith Bay, 1947.

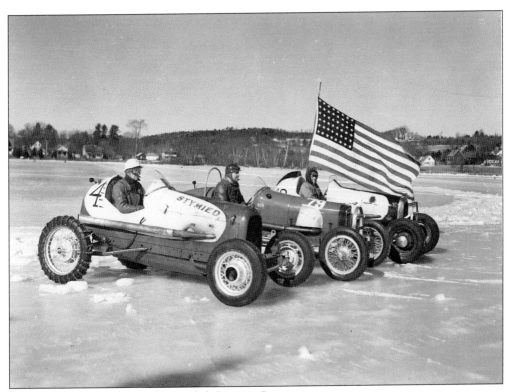

Drivers Preparing to Race on Meredith Bay, 1947.

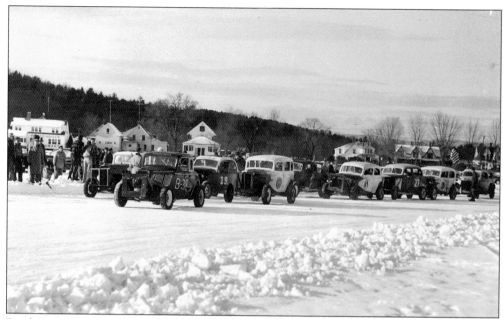

Stock Car Racing on Meredith Bay, 1960s.

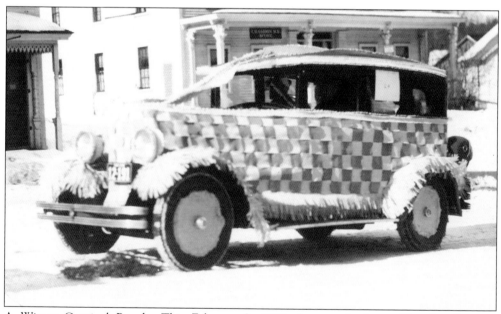

A Winter Carnival Parade. This February 3, 1928 photograph shows Olin Lund's auto, decorated for the parade. In the background is the present parking lot for the Advent Christian Church, Meredith Village.

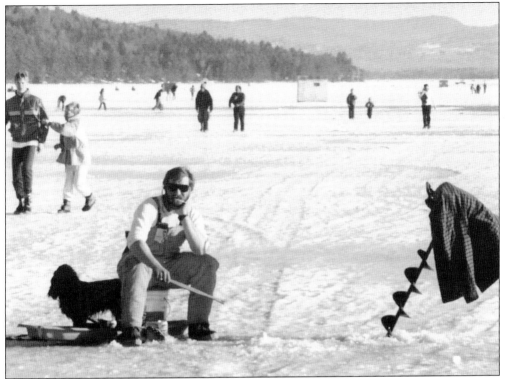

Ice Fishing on Meredith Bay. As long as I can remember, ice fishing has been a tradition in the Lakes Region. Every year, shortly after Christmas, ice begins to form across the lake, and one by one, the "bob houses" appear in the Bay, until hundreds are scattered across the "Big Lake."

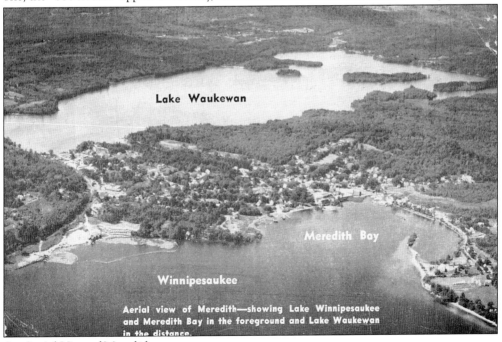

Lake Waukewan

Meredith Bay

Winnipesaukee

Aerial view of Meredith—showing Lake Winnipesaukee and Meredith Bay in the foreground and Lake Waukewan in the distance.

An Aerial View of Meredith.

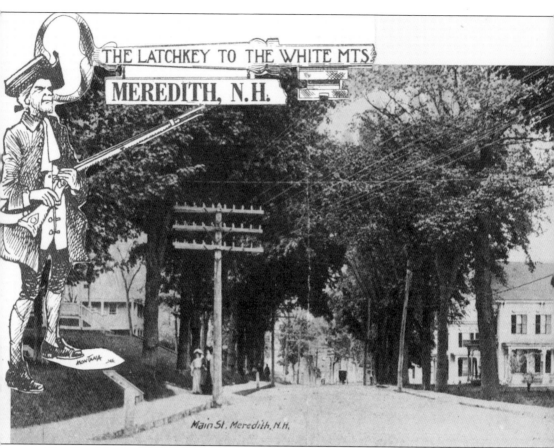

The "Latchkey"——Main Street, Looking North in Meredith Village.

Acknowledgments

Special thanks is extended to the following individuals for their contributions to this volume: Beverly Bacon, Barbara and Robert Bennett, Joanne Berry, Peg Bertholet, Flora Chandler, Marion Chase, Mr. and Mrs. Wayne Chase, Barbara Cogswell, Mrs. Allyson K. Curran, Harlan Faye, Robert Lamprey, Mr. and Mrs. Charles Lane, Louise H. LaPlante, Robert Lawton, the Meredith Historical Society, *The Meredith News*, Robert Murphy, William Pond, Carroll Richardson, Helen Schnoebelen, Rudy VanVeghten, *The Weirs Times and Tourists' Gazette*, Dorothy Wilkins, and Mr. and Mrs. Harold Wyatt.